IMAGES
of Aviation

THE 1910 LOS ANGELES
INTERNATIONAL AIR MEET

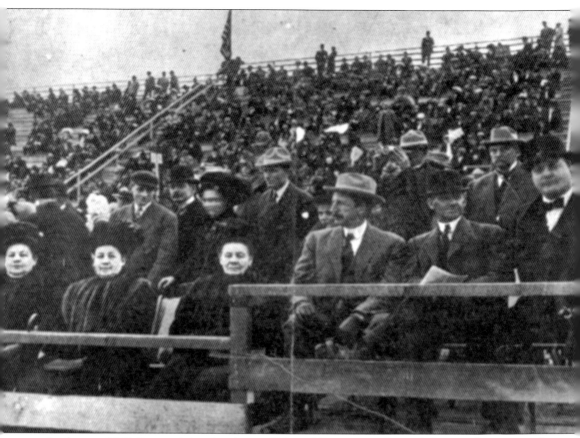

In the year 1910, five surviving daughters of Manuel Domínguez donated the use of a portion of their Rancho San Pedro property—Dominguez Hill—as the site for America's First International Air Meet. All five sisters had front-row box seats for the entire meet. The three sisters seen here in a photograph from the Los Angeles *Herald*, January 11, 1910, are, from left to right, Susana del Amo, Dolores Watson, and Guadalupe Domínguez. (California State University Dominguez Hills.)

ON THE COVER: Taken on Tuesday, January 11, 1910, at Dominguez Hill, this image shows lawyer and Los Angeles Polytechnic High School instructor Prof. J. S. Zerbe, attempting to take off in his Klassen-built multiplane machine. Newspaper sources relate that a loud cheer rose from the crowd as his contraption lumbered past the grandstand, sputtering and coughing as it churned up dust. Fortunately it did not leave the ground, and no one, including the embarrassed professor, was hurt. (California State University Dominguez Hills.)

IMAGES
of Aviation

The 1910 Los Angeles International Air Meet

Kenneth E. Pauley and the
Dominguez Rancho Adobe Museum

ARCADIA
PUBLISHING

Copyright © 2009 by Kenneth E. Pauley and the Dominguez Rancho Adobe Museum
ISBN 978-0-7385-7190-4

Published by Arcadia Publishing
Charleston SC, Chicago IL, Portsmouth NH, San Francisco CA

Printed in the United States of America

Library of Congress Control Number: 2009930172

For all general information contact Arcadia Publishing at:
Telephone 843-853-2070
Fax 843-853-0044
E-mail sales@arcadiapublishing.com
For customer service and orders:
Toll-Free 1-888-313-2665

Visit us on the Internet at www.arcadiapublishing.com

CONTENTS

ACKNOWLEDGMENTS

No book ever gets into publication without a great group of people helping it come to fruition. The Dominguez Rancho Adobe Museum gives the first credit to the Friends of Rancho San Pedro and its board of directors—William Barger; Kent Caldwell Cooper; Jean Huston-Walker; Thomas Huston; Br. Rene Lapage, CMF; Manny Marrero; John F. Watkins; and Jean Willard—for encouraging the museum to produce this book on the historic 1910 Los Angeles International Aviation Meet on Dominguez Air Field.

The Dominguez Rancho Adobe Museum wishes to thank the descendants of Manuel Domínguez for keeping the story of the Aviation Meet alive and for sharing their story with the public. Thanks to Fr. Pat McPolin for creating in the museum the two rooms dedicated to the Aviation Meet and the Early Birds. Thanks to all the Early Birds and aviators for bringing aviation to Southern California and sharing their wonderful stories. Deep gratitude goes to Ken Pauley, who wrote this wonderful book. If it were not for Ken's long and tireless hours and passion for the topic, this book would not have ever happened. He has been very generous with his materials, time, and support. Also thanks to his wife, Carol, for supporting his work on this project.

Finally, thanks to everyone involved in the aviation industry and those who support and promote the industry today.

—Alison Bruesehoff
Executive Director
Dominguez Rancho Adobe Museum

The author would like to express his thanks to the following people who gave selflessly of their time and expertise: Gregory Williams and Thomas Philo of California State University, Dominguez Hills, for allowing the use of images and memorabilia from their archives; aviation writer-historian John Underwood, for sharing items from his aviation collection; local historian-author James Osborne; fellow Los Angeles Westerners Michael Patris (also of the Mount Lowe Preservation Society), Nick Curry, and Paul Spitzzeri (also of the Workman and Temple Family Homestead Museum); and Alison Bruesehoff, who was a tremendous help in obtaining some vintage photographs. Heartfelt thanks go to Judson Grenier for reviewing and offering his expert advice for this publication.

Sources for the majority of images were the Archives/Special Collections of the California State University, Dominguez Hills (CSUDH), the Dominguez Rancho Adobe Museum (DRAM), the Security Pacific Collection/Los Angeles Public Library (LAPL), the Hatfield Collection at the Museum of Flight (TMOF/Hatfield), and the private collection of John Underwood. Other photographic credits are as noted.

—Kenneth E. Pauley

INTRODUCTION

This book commemorates the 100th anniversary of the 1910 Los Angeles International Aviation Meet at Dominguez Field. Commissioned by the Dominguez Rancho Adobe Museum, this publication is a tribute to the historic event of January 1910 at an airfield that no longer exists and to the Dominguez heirs who allowed the event to take place on their property.

The Aviation Meet was an event of extraordinary significance not only to Southern California but also to the entire western United States. The air meet introduced airplanes to a curious public who had never seen the powered, winged machines in public exhibitions. The meet would also feature dirigibles and balloons, but these lighter-than-air vehicles, flown for sport and exhibition throughout the nation, were not a novelty here.

Aviation received a boost in popularity after France dazzled the world with its First International Air Meet on August 22–29, 1909, on the plains of Béthany, north of the town of Rheims. According to movie newsreels and news reports around the world, the Rheims Air Meet was a roaring success. Aviator Louis Paulhan from France was a star attraction, as was American Glenn Curtiss, both of whom were prizewinners in aerial speed contests. It proved to a skeptical public that airplanes really could fly. It showed that they were no longer toys. And they could even carry passengers.

Aviation caught the imagination of inventors and aviators worldwide, providing the impetus to build and fly their machines. It convinced a group of flyers and enterprising businessmen in America to act quickly to organize an air meet to take place in a few months, in early 1910—one that would be international (with American and foreign aviators) and would rival the Rheims event.

Aviation Field atop Dominguez Hill, situated 13.5 miles due south from the plaza at Los Angeles, was the venue of the aviation meet that took place in January 1910. (Two others subsequently took place there.) The field has a gradual upward slope to the west. It is located on a portion of Rancho San Pedro, the homestead of Manuel Domínguez in the late 19th century. The original Spanish land grant of 75,000 acres had been given in 1784 to Manuel's granduncle, Juan José Domínguez, who received it upon his retirement as a Spanish soldier with the Portolá expedition. At age 22, Manuel inherited the rancho from his father, Cristobal. Four years later, in 1826, he completed building a home on the eastern slope of the mesa. He and his wife, María Engracia de Cota, had 10 children, of whom 6 survived. They raised their family at the rancho and lived there until Manuel's death in October 1882; María died less than six months later. The six Dominguez daughters who inherited the rancho preserved the family homestead and some of the surrounding land.

Thanks to the Dominguez daughters, aviation meet organizers were able to use a portion of the rancho without fee. The site had the characteristics desired for a public event: openness and safety; freedom from obstructions; proximity to rail and trolley depots; and a location high up on a mesa, requiring attendees to pay admission in order to see the events. The event was so successful that in December 1910, the Charity Aviation Corporation negotiated a five-year lease for annual meets. Two subsequent air meets were held at the same venue, one in December 1910 and another in 1912. But there were no others.

The vintage photographs that appear in this book are compelling but can only hint at the exhilaration of the participants and spectators. They put the reader in the aviator's seat or in the grandstand where one can witness firsthand what others had experienced a century ago.

The air meet was the start of America's transformation from agriculture to industry. It was appropriate that the parade on the final day was a salute to transportation titled "From Ox-Cart to Airplane."

The Dominguez family's adobe home attests to the largesse of the Dominguez daughters, who allowed the use of their property for the aviation event of January 1910. The Dominguez daughters donated the home, which is now a museum, and a few surrounding acres to the Claretian missionaries in 1924. Dominguez heirs still maintain ownership of parcels of land through the Carson Companies (Victoria Dominguez Carson's heirs) and the Watson Land Company (Dolores Dominguez Watson's heirs).

The Claretian Order, a religious congregation founded in Spain in 1849 and named after its founder Archbishop Anthony M. Claret, came to California in 1907. They were given charge of San Gabriel Mission and Our Lady Queen of the Angels, and through the latter church, they became acquainted with the Dominguez family. On the property, the Claretians built a seminary called the Dominguez Memorial Seminary.

Today the adobe home is a museum maintained in the style of the early rancho period. It is California Historical Landmark No. 152 and has been listed on the U.S. Department of the Interior's National Register of Historic Landmarks since 1976. It serves as a reminder of early Spanish settlement in California. It embodies the long and colorful history of Juan José Dominguez, who was one of the Spanish soldiers in the band accompanying Junípero Serra in the march from Baja California up to San Diego in 1769, and of his descendants, who also made history with use of their land.

The Dominguez Rancho Adobe Museum has devoted two rooms to display memorabilia of the historic Los Angeles International Aviation Meet that took place on the Dominguez property. A large diorama displayed in the museum depicts the events of the January 1910 Aviation Meet. Memorabilia of the meet and the two subsequent ones in December 1910 and January 1912 are also proudly displayed.

The Dominguez air meet sometimes receives only a passing mention in general aviation books that profess to cover aviation over the last 100 years, but it was an important event and one that generated enthusiasm for aviation in Southern California and throughout the United States. It influenced many young men to become aviators and engineers and to start their own manufacturing companies, and famous they became. It encouraged innovation and propelled Southern California's economy to greatness. A huge aerospace industry grew from that humble beginning.

Two classic works, published in the 20th century, commemorate significant milestones for the Aviation Meet at Dominguez Field. "America's First International Air Meet" by J. Wesley Neal for the *Historical Society of Southern California Quarterly* (December 1961) celebrates the air meet's 50th anniversary. *Dominguez Air Meet* (1976) by David D. Hatfield marks the 150th anniversary of the Dominguez Rancho Adobe. This current book, published in the 21st century, commemorates the 100th anniversary of the air meet. It is hoped that this centennial is a precursor to other milestone celebrations.

The museum is operated by the Friends of Rancho San Pedro to preserve and increase community awareness of early California history as it relates to the Dominguez family, the homestead adobe, and the Rancho San Pedro. At the juxtaposition of Dominguez family history and aviation history, the museum also preserves aviation memories of America's First International Air Meet.

One

RHEIMS TO
LOS ANGELES

Aviators and aeronauts flying their new machines and performing daring aerial feats were causing a sensation in Europe in 1909. Air exhibitions attracted curious and thrill-seeking throngs. At the world's first International Air Meet at Rheims, France, held for one week in August 1909, Glenn H. Curtiss was the only American entrant among the flyers. To everyone's surprise, he won the Coupe Gordon Bennett race by clocking in at 46.5 miles per hour and the *Prix de la Vitesse* (the Speed Prize) and took second place in the *Prix de Tour de Piste*. He garnered 36,000 francs (about $5,000) in prize winnings, in addition to bringing home the coveted Gordon Bennett Cup. After Rheims, Curtiss went on to the town of Brescia, Italy, where he entered another competition, winning the "Grand" and "Altitude" prizes and $7,000 more in cash, before his return to America in September.

The Frenchman Louis Paulhan, approximately age 25, was Glenn Curtiss's archrival of the air. He was employed as a mechanic with the Voisin airplane plant at Paris. He submitted an entry in a design contest sponsored by the airplane manufacturers Voisin and Farman. He won this contest and received a new Farman biplane as first prize. About the same time, he tested and publicized engines manufactured by Gnôme. Paulhan quickly learned to fly, and soon after, on August 25, 1909, at Béthany, France, he set a dual distance and speed record that made him famous around the world.

The Rheims Air Meet captured the imagination of American aviators, inventors, and entrepreneurs, who rushed in to capitalize on aviation's newfound popularity. Some of them formed a group to organize a second air show, this time to be held in the United States. This meet would be the world's second international air meet but America's first.

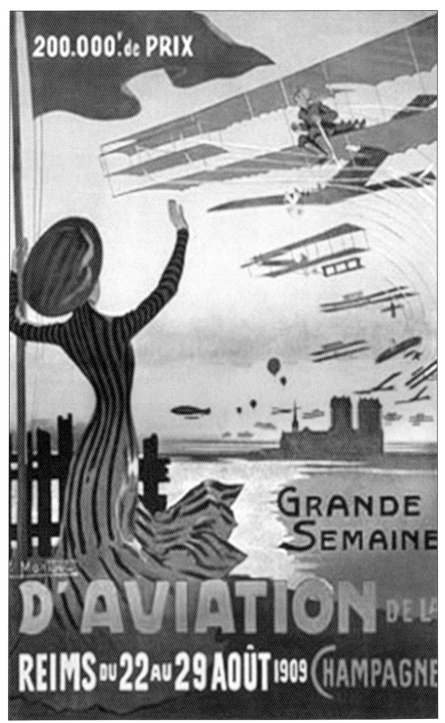

The age of aviation came into being with the world's first aviation competition at Rheims, France. This poster advertises the Grand Week of Aviation at Champagne at Rheims from August 22 to 29, 1909, with 200,000 francs offered in prize money. Artist Earnest Montaut created this evocative color lithograph. (CSUDH.)

Glenn Curtiss is seated in his Rheims Racer. He has his usual dour expression, even after he won the prestigious James Gordon Bennett Cup. He set a record of 15 minutes and 50 3/5 seconds, or 47.07 miles per hour, for the fastest two circuits of the course, each circuit being 10 kilometers or 12.428 miles total. His prize was $5,000. He brought back the trophy to his home club, the Aero Club of America. (Musée de l'Air et de l'Espace de Paris.)

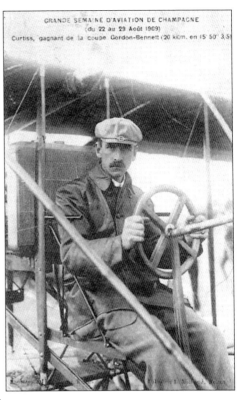

GRANDE SEMAINE D'AVIATION DE CHAMPAGNE
(du 22 au 29 Août 1909)
Curtiss, gagnant de la coupe Gordon-Bennett (20 kilm. en 15' 50' 3.5)

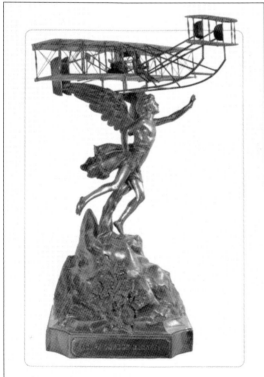

The James Gordon Bennett silver trophy was the most coveted prize awarded at the world's first international air meet at Rheims, France, in 1909. The graceful statuary shows a winged figure flying in the breeze beneath an early-model Wright biplane. Ironically, Glenn Curtiss, the Wright brothers' archrival at the time, won the trophy. (CSUDH.)

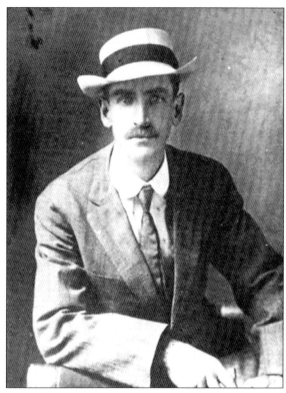

Glenn Curtiss poses for a formal portrait. After accomplishing sensational aerial feats in Europe, he returned home and continued to manufacture and sell aviation motors and aircraft at his G. H. Curtiss Manufacturing Company. (Hatfield.)

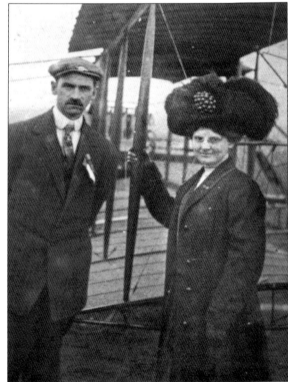

Glenn Curtiss and his wife, Lena, stand in front of a Curtiss Flier at the January 1910 Dominguez air meet. She is stylish and formal with her gloves and enormous hat. He appears to be his usual businesslike self. (Hatfield.)

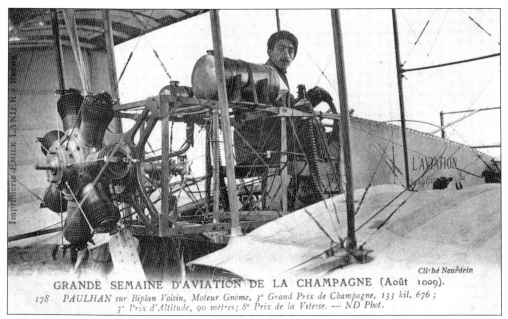

Imprimerie ÉMILE LANIER · Rennes

Cliché Neurdein

GRANDE SEMAINE D'AVIATION DE LA CHAMPAGNE (Août 1909).
178 PAULHAN sur Biplan Voisin, Moteur Gnôme, 3ᵉ Grand Prix de Champagne, 133 kil. 676 ;
3ᵉ Prix d'Altitude, 90 mètres; 8ᵉ Prix de la Vitesse. — ND Phot.

This French postcard celebrates Paulhan for the prizes he won in three races at the Grand Week of Aviation at Champagne in August 1909. Paulhan is in his Voisin biplane with Gnôme engine. He won third place in the Grand Prix de Champagne, for a distance of 133 kilometers, third place for altitude of 90 meters, and eighth place for speed for three times around the circuit (30 kilometers). (Musée de l'Air et de l'Espace de Paris.)

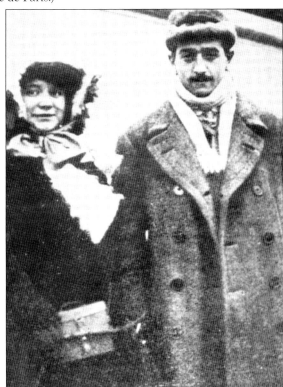

When he worked for the Voisin airplane manufacturer in the spring of 1909, Paulhan was known as "Le Petit Meccano," an appropriate name for a 5-foot-4-inch-tall, 140-pound man who was also a tightrope walker in a circus in early 1909. He is seen here with his wife, Celeste, who is even more petite. (Hatfield.)

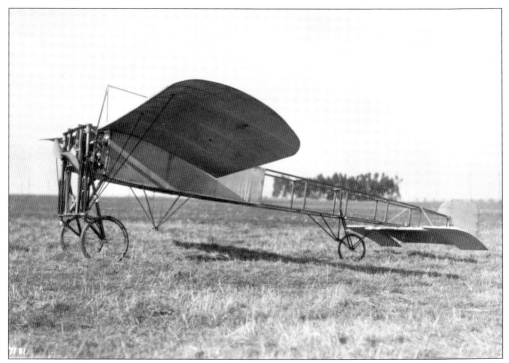

This postcard shows one of two Blériot XI monoplanes resting on a field. Louis Paulhan brought two models like this with him to Dominguez Hill in 1910. (CSUDH.)

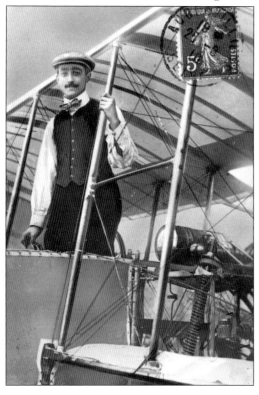

Always the confident *pilote-aviateur*, Louis Paulhan stands on the bottom wing of his Voisin box-kite biplane and appears ready for any competitive event at the 1909 Rheims Air Meet. (Musée de l'Air et de l'Espace de Paris.)

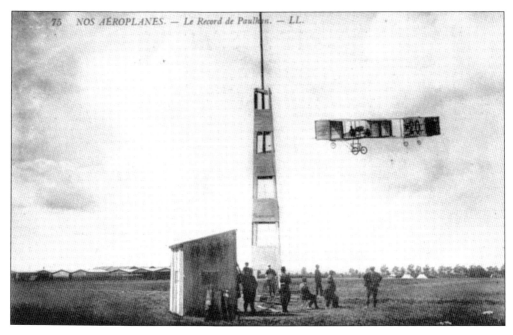

Louis Paulhan is seen flying the Voisin box-kite biplane (No. 20) around a pylon at the 1909 Rheims Air Meet (above). Despite being new to aviation, Paulhan placed in three events during the eight-day event. On the sixth day, however, he crashed the Voisin but emerged unscathed (below). A large and curious crowd gathers at the crash scene. At Rheims Paulhan gained valuable flying experience, which he put to good use at the Dominguez Air Meet held the following year. (Above, CSUDH; below, Musée de l'Air et de l'Espace de Paris.)

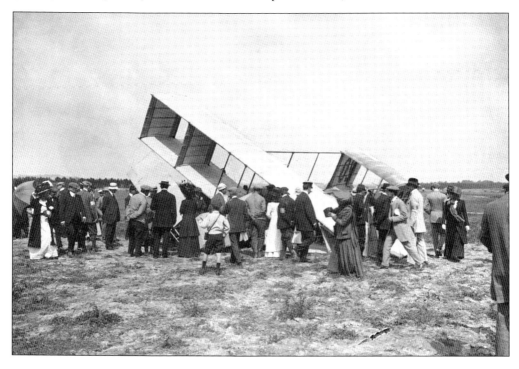

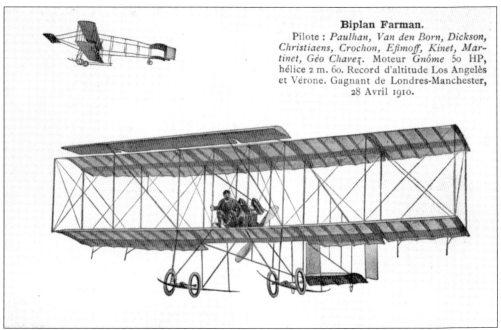

Biplan Farman.

Pilote : *Paulhan, Van den Born, Dickson, Christiaens, Crochon, Efimoff, Kinet, Martinet, Géo Chavez*. Moteur *Gnôme* 50 HP, hélice 2 m. 60. Record d'altitude Los Angelès et Vérone. Gagnant de Londres-Manchester, 28 Avril 1910.

This is an artist's conception of the French standard Henri Farman biplane. The caption reads that it had nine pilots, one of whom was Louis Paulhan. The propeller was about 8.5 feet (2.6 meters). The Farman won the international competition at Los Angeles in 1910 and at Vérone, France, for altitude. It also won the London-Manchester race on April 28, 1910. (CSUDH.)

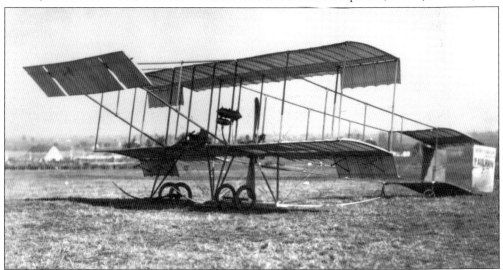

The smaller of Louis Paulhan's two Farman biplanes rests on Aviation Field. There are three major differences between the small and "standard" size Farman biplanes. First, the fuel tank is considerably smaller on the small version. Second, although they both have Gnôme engines, the smaller has 38 horsepower and the standard has 50 horsepower. Third, their empennage or tail section configurations are different. The smaller Farman had a Voisin-like box-kite tail arrangement (seen with PAULHAN painted on the side). The standard or Farman II had a tail with larger horizontal panels on top and bottom supported by a centrally located vertical sheet panel that acted as a rudder. (CSUDH.)

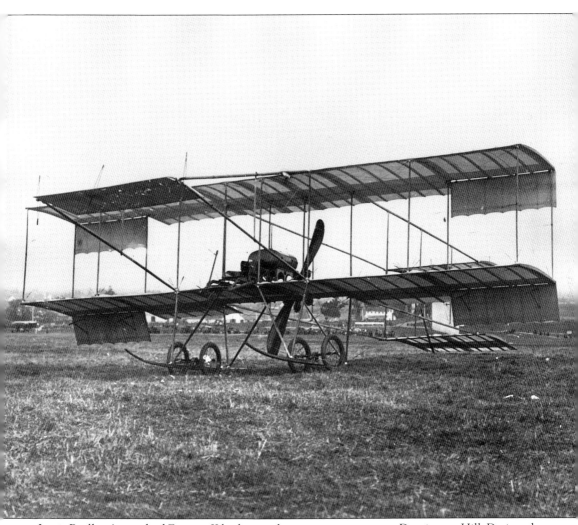

Louis Paulhan's standard Farman II biplane is shown at rest on grass at Dominguez Hill. Designed by French aviator and inventor Henri Farman and based on similar aircraft produced by the Voisin brothers of France, the Farman biplane received popular acceptance by early aviators, notably Paulhan, Van den Born, Dickson, Christiaens, Crochon, Efimoff, Kinet, Marrinet, and Géo Chaviz. Wingspan was 34 feet 10 inches, length 38 feet, height 10 feet 9 inches, and weight fully loaded 816 pounds. The engine was an air-cooled Gnôme seven-cylinder radial engine, rated at 50 horsepower. At the 1910 January air meet, Paulhan flew this machine on many of his competitive and recreational excursions, setting new world records in his Farman. (John Underwood.)

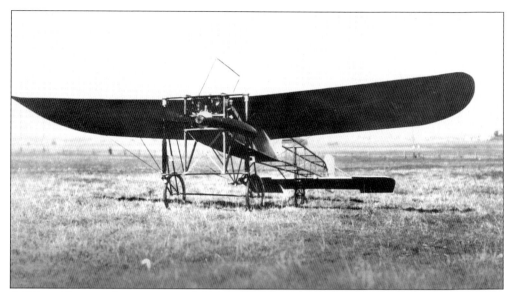

A Blériot XI monoplane rests on a field. This is the same model that Louis Blériot used to cross the English Channel on July 25, 1909. Paulhan brought two models like this one to the Dominguez air meet in order to compete and to use as training machines for his mechanics, Charles Miscarol and Didier Masson, who were also his flying students. (CSUDH.)

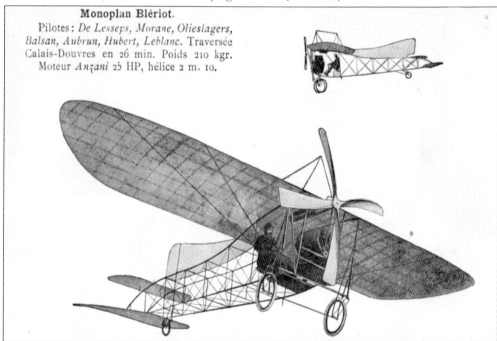

Monoplan Blériot.
Pilotes: *De Lesseps, Morane, Olieslagers, Balsan, Aubrun, Hubert, Leblanc.* Traversée Calais-Douvres en 26 min. Poids 210 kgr. Moteur *Anzani* 25 HP, hélice 2 m. 10.

Shown in this artist's drawing is the French Blériot XII monoplane, which was flown at Rheims in August 1909. An earlier model, the XI, was flown across the English Channel. The caption indicates that seven pilots flew the XII and the Calais-to-Douvres course was completed in 26 minutes. The caption gives the weight as 210 kilos (463 pounds). The engine was a 25-horsepower Anzani that was air-cooled with three radial cylinders. The propeller was 2.6 meters (about 6.9 feet) in diameter. (CSUDH.)

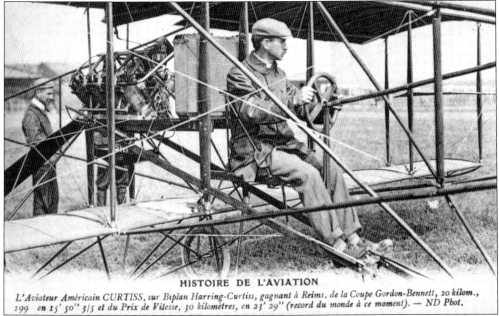

L'Aviateur Américain CURTISS, sur Biplan Harring-Curtiss, gagnant à Reims, de la Coupe Gordon-Bennett, 20 kilom., 199 en 15' 50" 3/5 et du Prix de Vitesse, 30 kilomètres, en 23' 29" (record du monde à ce moment). — ND Phot.

This French postcard shows American aviator Glenn Curtiss sitting on his Herring-Curtiss biplane after winning, the *Prix de Vitesse*, the speed prize, at Rheims, France. This biplane was not the Curtiss *Golden Flier* but the specially built Rheims Racer, with chopped wings and Curtiss 50-horsepower, water-cooled V-8 engine. The speed race for 30 kilometers was made in 23 minutes and 29 seconds, which was a world record at the time. (Musée de l'Air et de l'Espace de Paris.)

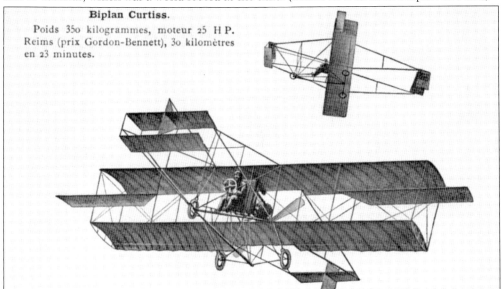

Biplan Curtiss.

Poids 350 kilogrammes, moteur 25 H P.
Reims (prix Gordon-Bennett), 30 kilomètres
en 23 minutes.

This artist's sketch shows a view of the Curtiss *Golden Flier* (Model D), often mistaken for the Rheims Racer that Curtiss flew at Rheims in 1909. The weight is stated as 350 kilograms (771 pounds), but Curtiss's own specification placed the Model D at 550 pounds gross or 249 kilograms. According to Charles Willard, the motor delivered only 22.5 horsepower. This model was not flown in the Prix Gordon Bennett race, so the winning time of 23 minutes shown is irrelevant. The Rheims Racer did win in a time of 15 minutes, 50 seconds. (CSUDH.)

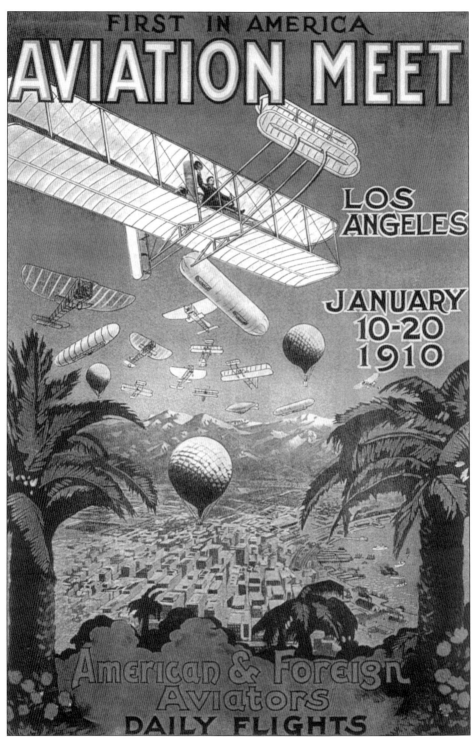

Aviation comes to town. This colorful poster advertises America's first international air meet, featuring both American and foreign aviators. It invites the public to come along for the ride of a lifetime. (CSUDH.)

Two

An American First

Aviator Glenn Curtiss returned to the United States from his European success at the Rheims Air Meet. News of his aerial prowess spread quickly. He accepted an offer by Albert Bond Lambert, a leading industrialist and aviation promoter, of $5,000 to fly his *Golden Flier*—Lambert was mistaken and meant the Rheims Racer—at the St. Louis, Missouri, exhibition in October the following month.

In the meantime, serendipity brought together aviator Charles F. Willard and aeronaut Roy Knabenshue in Latonia, Kentucky, in September. Willard was there to fulfill an exhibition contract, and Knabenshue was also there "on the circuit," making exhibition flights in his dirigible. The two discussed their future flying bookings, which were slim. Both men were eager to generate work for themselves at a time when the public's appetite for aviation was whetted. Together they came up with the idea of holding an air meet in America and decided they had to act quickly since winter was approaching. They called Glenn Curtiss in Hammondsport, New York, who agreed to participate with them in a meet to be scheduled in Los Angeles after Curtiss's October air exhibition in St. Louis. At St. Louis, Curtiss, Willard, and Knabenshue joined forces with aeronauts Capt. Thomas S. Baldwin and Lincoln Beachey, who were also there. They banded together in an informal flying alliance headed up by Knabenshue.

Knabenshue was a promoter of several aviation events in which he also participated. He convinced the other aviators at St. Louis that a first-class air meet should be held, with as many famous aviators and their flying machines as possible. Knabenshue contacted promoter and balloon enthusiast Dick Ferris, who in turn obtained the support of Max Ihmsen, general manager of the Los Angeles *Examiner*. Ihmsen was instrumental in convincing the Frenchman Louis Paulhan to attend with an incentive of $50,000. Paulhan's presence would make the meet international. Ferris also solicited and got financial backing from the Los Angeles Merchants and Manufacturers Association.

Curtiss and Willard found a suitable site for the air meet in Los Angeles, and preparations began. And as they say, things got off to a flying start.

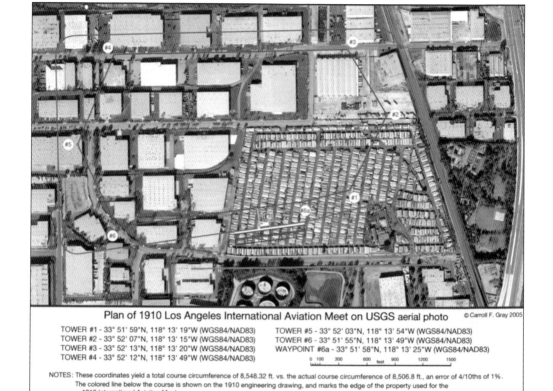

Plan of 1910 Los Angeles International Aviation Meet on USGS aerial photo © Carroll F. Gray 2005

TOWER #1 - 33° 51' 59"N, 118° 13' 19"W (WGS84/NAD83)	TOWER #5 - 33° 52' 03"N, 118° 13' 54"W (WGS84/NAD83)
TOWER #2 - 33° 52' 07"N, 118° 13' 15"W (WGS84/NAD83)	TOWER #6 - 33° 51' 55"N, 118° 13' 49"W (WGS84/NAD83)
TOWER #3 - 33° 52' 13"N, 118° 13' 20"W (WGS84/NAD83)	WAYPOINT #6a - 33° 51' 58"N, 118° 13' 25"W (WGS84/NAD83)
TOWER #4 - 33° 52' 12"N, 118° 13' 49"W (WGS84/NAD83)	0 100 300 600 feet 900 1200 1500

NOTES: These coordinates yield a total course circumference of 8,548.32 ft. vs. the actual course circumference of 8,506.8 ft., an error of 4/10ths of 1%. The colored line below the course is shown on the 1910 engineering drawing, and marks the edge of the property used for the 1910 International Aviation Meet.

The racetrack-like course for the 1910 Los Angeles Aviation Meet is shown superimposed on a U.S. Geological Survey aerial photograph. (North at top.) Produced by Carroll F. Gray in 2005, it shows the surveyed coordinates for each of the six 10-foot pylons placed around the hexagonal border and a waypoint. (DRAM.)

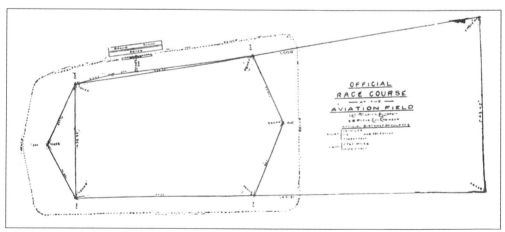

The hexagonal planned course originally had a circumferential distance of 8,506.8 feet or 1.611 miles, shown here on a map from the January 18, 1910, Los Angeles *Herald*. Because turns in the tight curves on the ends of the track forced the aviators to turn wide and fly over the grandstands, the officials later extended the track to 14,578 feet or 2.761 miles toward the west. (North at bottom.) (Hatfield.)

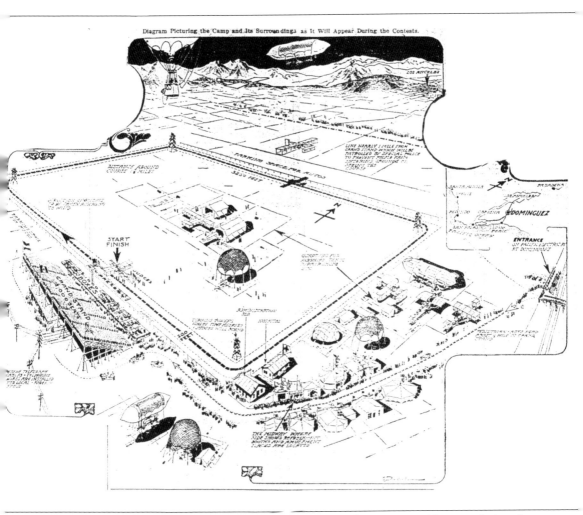

Diagram Picturing the Camp and Its Surroundings as It Will Appear During the Contests.

An artist's conception shows Aviation Camp and its surroundings as it would appear during the contests. The perspective shows the compass heading and the relative positions of the racecourse, the walkway from the train depot to the grandstand, and the intended course. Details as to service tent types, course shape (it became hexagonal not rectangular), and size were later changed for the event. (CSUDH.)

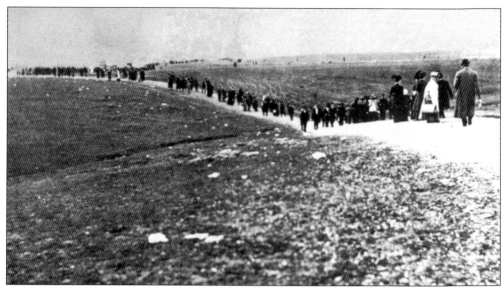

On the first day of competition (Aviation Day), Monday, January 10, between 10,000 and 15,000 spectators walked from the Southern Pacific railroad terminal up the graded path about a half-mile to Aviation Field. The night before, it had rained, and the Aviation Committee had to scatter 1,260 bales of sawdust along all walking paths to provide protection to visitors from the mud. (TMOF/Hatfield.)

Southern Pacific steam trains were the most popular means of transporting crowds to the station entrance of Dominguez Field. Rides cost 35¢ round-trip (40¢ if purchased on the train). They left Arcade Station at Fifth and Central Avenue in downtown Los Angeles six times daily from 9:05 a.m. to 1:30 p.m. The advertisement suggests, "Take Your Lunch and Start Early." People also came by Pacific Electric Trolley, automobile or horse carriage, or on foot. (CSUDH.)

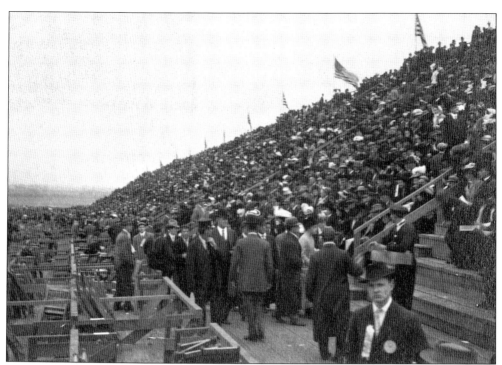

Stereograph shows thousands of spectators in the grandstand before the start of the meet on opening day, January 10, 1910. J. Wesley Neal's "America's First" reports that "a million board-feet of lumber and seven hundred thousand spikes were used for the grandstand." American flags wave in the midday breeze. (CSUDH.)

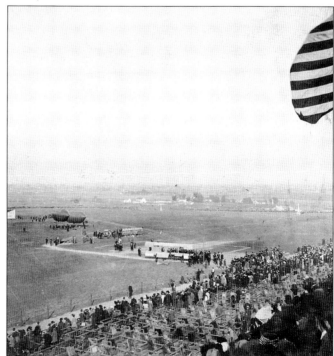

Sitting atop a rail seat on the grandstand, a spectator using a box camera captures the start of a flight by Louis Paulhan in his Farman biplane. (DRAM.)

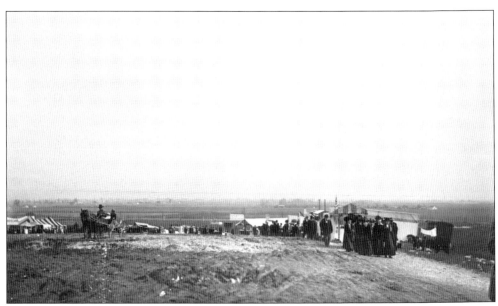

On the first day of competition, at the end of their one-half-mile hike, spectators arrive at the concession area where food and drinks and booths with odd attractions awaited them. (TMOF/Hatfield.)

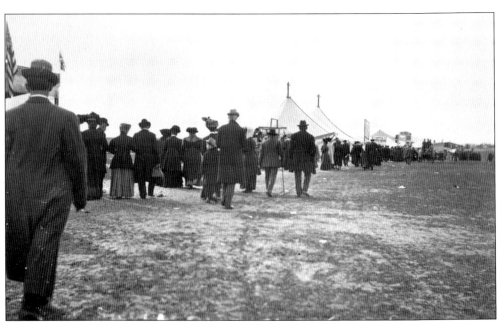

On day two of the meet, Tuesday, January 11 (Los Angeles Day), crowds enter Aviation Field but must pass concession tents and booths that line the walkway east of the grandstand. (TMOF/Hatfield.)

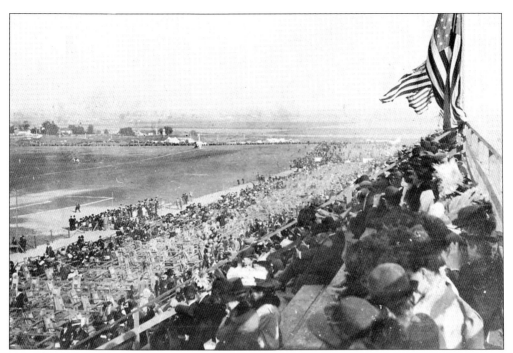

From the top of the grandstand on opening day of the meet, a spectator photographed this broad view of the crowd and grandstand looking to the east. American flags are stationed on the top railing and spaced about every 15 feet. (DRAM.)

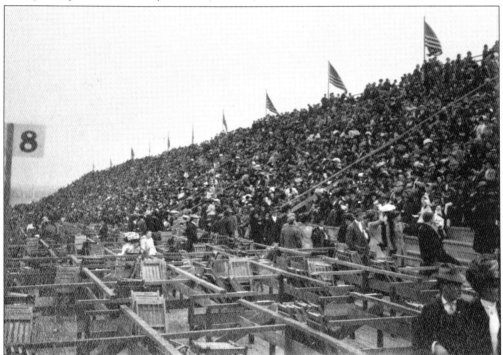

This stereograph view shows the grandstand with people awaiting the start of America's First International Air Meet. (John Underwood.)

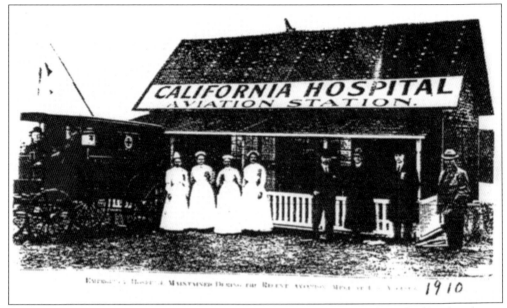

CALIFORNIA HOSPITAL
AVIATION STATION.

Exerg... Hospital Maintained During the Recent Aviation Meet at Los Angeles 1910

Newsreels and newspapers raced one another to attract spectators looking for blood and guts. They showed several (only four deaths through 1909) gruesome aviation accidents to date. It was reported in the Los Angeles *Examiner*, on January 5, 1910, that "ambulance and emergency equipment would be on the grounds at all times." The makeshift Aviation Station of California Hospital was there specifically to supply all emergency equipment and personnel for the meet. Edgar Smith, who is seen below in his *Dragonfly II* tandem monoplane, was a beneficiary of the emergency services. On the second day of the meet, Smith was hit on the head by his propeller and sustained a gash to his head. The ambulance zipped past J. S. Zerbe, who at the same time had an accident in his multiplane and thought it was meant for him, to pick up Smith and rushed him to California Hospital. (Above, CSUDH; below, John Underwood.)

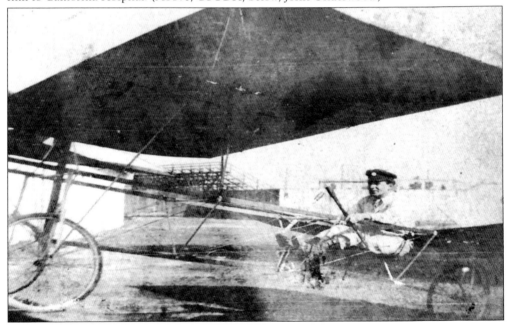

A cartoon depicts a crowd of hatted, fashionably dressed women whose faces are turned upward. Air meet sponsors wanted to increase female attendance, so promoting fashionable clothing for Aviation Week was a smart move on the part of advertisers. (CSUDH.)

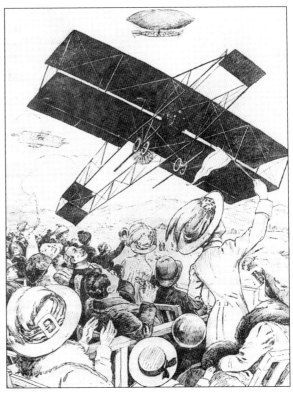

Los Angeles businesses displayed creativity in linking their products to the aviation theme. They advertised items, ranging from women's fashion to optical glasses to automobile accessories. This drawing appeared in the Los Angeles *Times* newspaper on January 2, 1910, and prepares women for the beginning of a week of aviation fashion. (CSUDH.)

The postcard above asks the question, "Why Shouldn't We Fly?" Why indeed, as this little cherub takes the controls of the new biplane and roars into the air, advertising Aviation Week. Below, this postcard with a sky full of planes and balloons sends greetings from California. Many such postcards and greeting cards, some with foldouts, were sent around the world from Los Angeles. Postcards and newspaper photographs teased audiences with composite images made from separate still shots. Montages were used for aviation promotion and were popular during the early 1900s. (Both, CSUDH.)

MUCH INTEREST IN CURTISS BIPLANE BECAUSE OF PATENT RIGHTS LITIGATION

A GLENN CURTISS BIPLANE

Deep interest is manifested in the outcome of a suit in the New York supreme court regarding infringement on the patent rights of aeroplanes. The contest is on between Glenn Curtiss, the well-known aviator, and the Wright brothers. If the case is decided in favor of Curtiss anybody will have a right to manufacture aeroplanes. On the other hand if the Wrights win the suit a royalty on flying machines will be exacted.

In the accompanying illustration is shown a Curtiss machine upon which the Wrights declare the infringement exists. The principal difference between the machines is that the Curtiss machine uses a box steering gear while the rudder on the Wrights' machine is biplane apparatus.

The Curtiss aeroplane uses wheels on the under structure, while the Wrights use skids. Both styles of aeroplanes have been using 40 horsepower engines.

Los Angeles enthusiasts have learned that Curtiss is coming to this city with a new and powerful engine that he has invented and perfected, with which he expects to annex additional honors.

Curtiss has carefully guarded his new engine, and the fact that he has been working on such a piece of mechanism, and this is the first announcement of that fact. When the meet opens it is likely that there will be other sensations in aeroplane construction, as the tenor of his defi shows that he evidently has something worth while up his own sleeve.

The Dominguez air meet almost did not happen. As early as September 30, 1909, the Wright brothers had sued Glenn Curtiss to prevent him from selling air machines with the aileron design that they claimed was protected by their patent. Learning of the upcoming Dominguez event, the Wrights sought to prevent it and to keep Curtiss from taking part. Fortunately, a New York judge postponed this litigation until after the meet took place. The Wrights' litigiousness had some sobering consequences on aviation development for the next few years. The French and Glenn Curtiss, too, bypassed the brothers' invention with ones of their own. By 1910, French manufacturers, notably Voisin and Farman, had dispensed with wing-warping for roll control. Their own invention, the "aileron," dispensed with wing-warping. A new lexicon with French appellations came about, as French aeronautical engineers were designing new components with names such as "fuselage," "empennage," "nacelle," and, of course, "aileron." It has been argued that the Wrights would have been more productive if they had occupied themselves with aviation and spent more time in their bicycle shop and laboratory rather than in the courtroom. (CSUDH.)

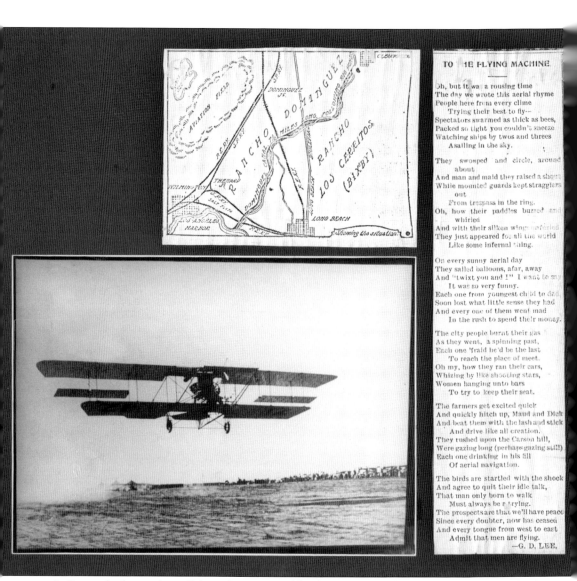

A Curtiss biplane takes off from Aviation Field. The map inset shows the locale. G. D. Lee's poem "To the Flying Machine" graces the sidebar with a reflection that finally one must "admit that men are flying." (CSUDH.)

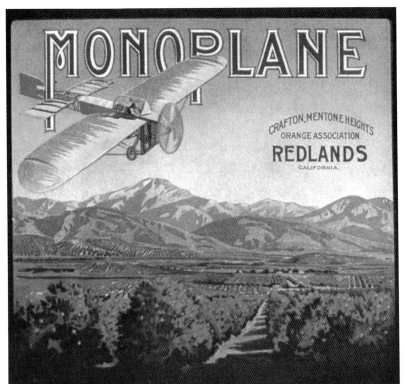

Local businesses, such as the Orange Association in Redlands and the Cawston Ostrich Farms of South Pasadena, advertised their products with flair. (Right, CSUDH; below, DRAM.)

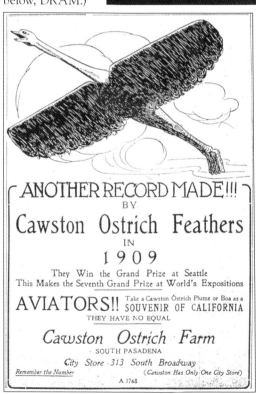

33

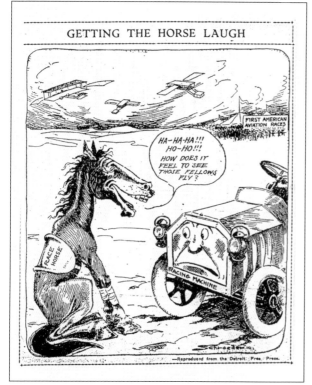

Cartoonists got into the spirit of current aviation. A horse laments his and the car's fate at the mercy of fast air activities. (CSUDH.)

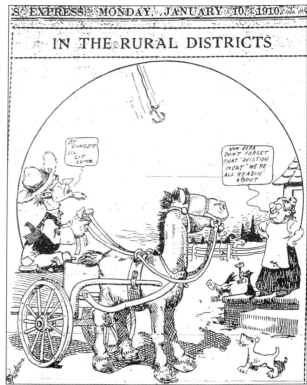

A cartoonist pokes fun at Ezra in his cart drawn by a broken-down nag. This is obviously a reference to Ezra Meeker of Oregon Trail fame. (CSUDH.)

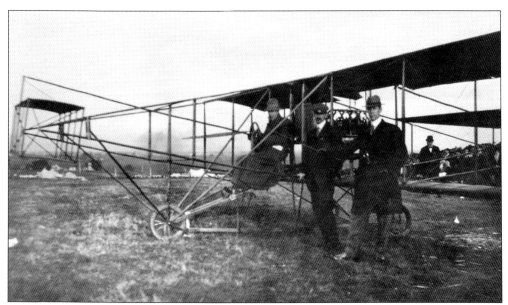

The Glenn Curtiss Flying Team brought four Curtiss Fliers with them to the January air meet. This Model D1 Flier has the usual water-cooled four-cylinder engine, but it sports a four-bladed propeller—"the only one of the kind on the ground," according to the Los Angeles *Times*, January 17, 1910. This is the Flier that Charles K. Hamilton flew during the meet. Aviators seen next to the biplane are, from left to right, Hamilton (or possibly Lincoln Beachey), Glenn Curtiss, and Roy Knabenshue. (Workman and Temple Family Homestead Museum.)

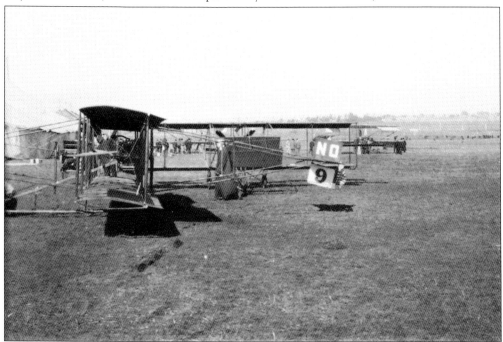

This stereograph shows the Curtiss Model D1 machine, the 22.5-horsepower *Golden Flier*, resting on grass after being assembled at Aviation Field. Charles F. Willard owned and flew this small biplane that was slow but accurate. (CSUDH.)

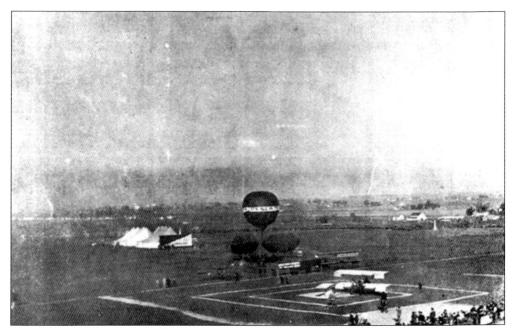

On the first day of the meet, the skies were clear with a few fluffy clouds and slight ocean breeze. Aviation activity begins on the field where balloons, dirigibles, and Louis Paulhan's large Farman are all ready for takeoff. (CSUDH.)

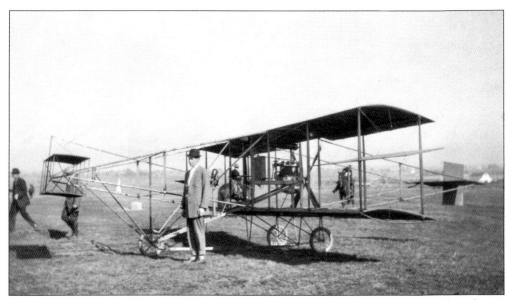

Roy Knabenshue stands in front of the Curtiss Flier that was used by Charles K. Hamilton during the meet. The only four-bladed propeller used by any air vehicle in the meet, it must have influenced the results that Hamilton achieved. He won for slowest lap, 1.61 miles in 3 minutes 36 2/5 seconds. For this, he was awarded $500. (Workman and Temple Family Homestead Museum.)

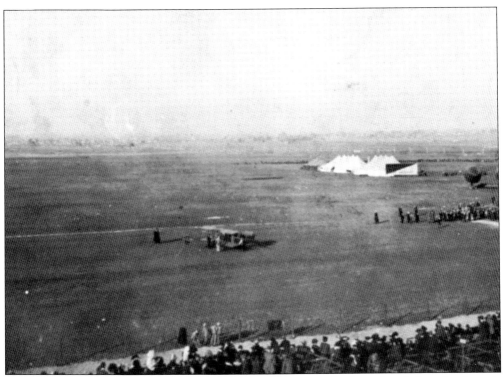

Curtiss flew Willard's *Golden Flier* on the first day and became the first pilot of a heavier-than-air machine to make a flight in the West. (CSUDH.)

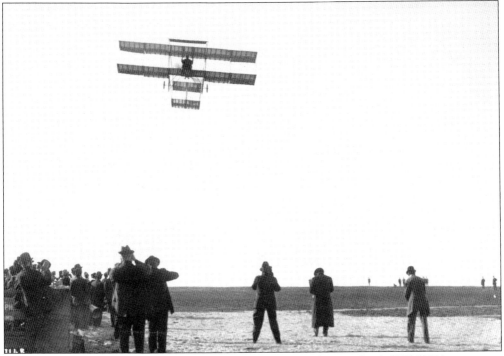

Fans and judges roam near the box seats while a biplane is about to land. (CSUDH.)

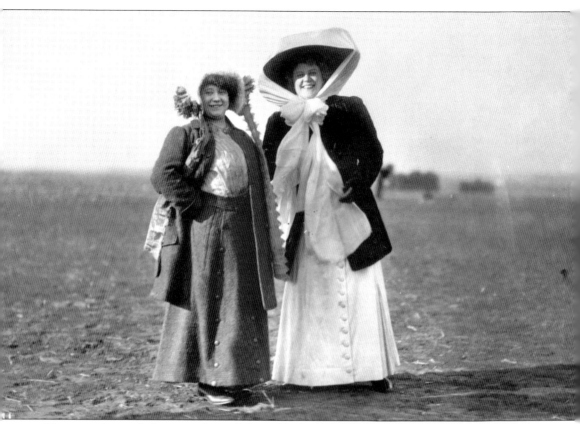

These two famous ladies were always fashionably dressed even when they were aloft in airplanes and balloons. On the left is Celeste Paulhan, wife of aviator Louis Paulhan, and on the right Mrs. Dick Ferris, wife of the air meet promoter and a well-known singer and stage performer, known professionally as Florence Stone. During Aviation Week, the two women "exchanged husbands" when Madame Paulhan flew in the balloon *Dick Ferris* and Mrs. Ferris flew with Paulhan in his Farman II biplane. (LAPL.)

Three

THE SIDESHOW
AND ODDITIES

The meet had a circus-like atmosphere. On the way to the grandstands, there were tents with motley attractions unrelated to aviation. Barkers were stationed outside hastily erected tents and booths on the paths leading to the grandstand. They bellowed out: "Fatima, the Sultan's Delight has just arrived, a mother snake and her 'five little ones.'" Shouted from a megaphone was the question "Have you seen Trixie, the fattest girl in the world?" Other attractions were loudly exclaimed: "The Secrets of the Egyptian Pyramids!" and "Cora-Etta," a version of Siamese twins appropriately called "The Human Bi-plane."

Boys were selling peanuts, candy, and Cracker Jack. Concessions for food and drink stretched along the opening path to the grandstand. As one might expect from any large event, the venue held a captive audience who had to walk half a mile to gain entrance and once inside, did not find a gourmet's delight. A news reporter who attended the meet wrote, "The *bon vivant* found neither appeal nor pleasure with what was there and a nickel cup of coffee cost a whopping 10¢."

On the first day of the meet, attendance was estimated to be about 15,000. The crowd was festive though somewhat skeptical that these machines could fly, but they were there to be entertained.

There were inventors who brought fanciful and bizarre flying machines to the meet. Notable were Prof. J. S. Zerbe and his multi-winged plane, Prof. H. LaV. Twining and his ornithopter, Jacob Klassen and his monoplane, and Edgar Smith and his tandem monoplane, which a reporter waggishly dubbed "the rowboat that had sprouted wings." Other inventors, designers, and mechanics tried to complete their odd flying contraptions outside the fence but could not finish.

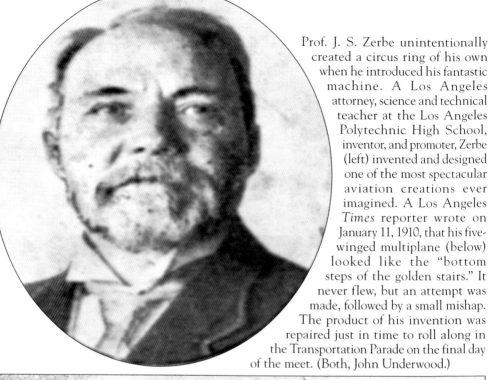

Prof. J. S. Zerbe unintentionally created a circus ring of his own when he introduced his fantastic machine. A Los Angeles attorney, science and technical teacher at the Los Angeles Polytechnic High School, inventor, and promoter, Zerbe (left) invented and designed one of the most spectacular aviation creations ever imagined. A Los Angeles *Times* reporter wrote on January 11, 1910, that his five-winged multiplane (below) looked like the "bottom steps of the golden stairs." It never flew, but an attempt was made, followed by a small mishap. The product of his invention was repaired just in time to roll along in the Transportation Parade on the final day of the meet. (Both, John Underwood.)

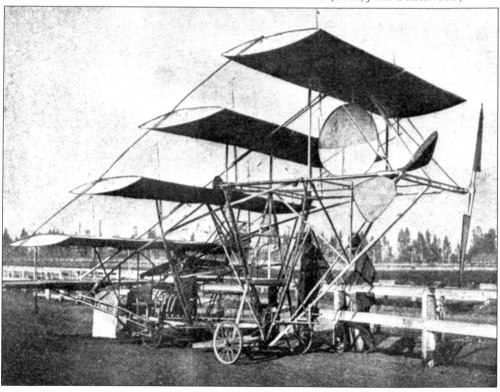

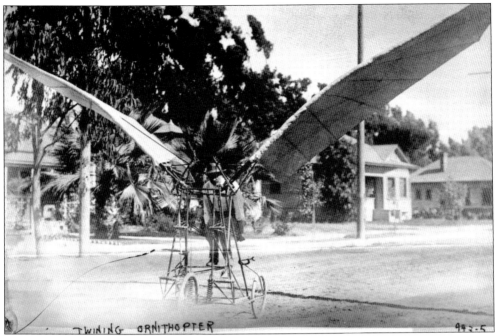

TWINING ORNITHOPTER 943-5

Prof. H. LaV. Twining (below), a Los Angeles Polytechnic High School instructor and aviation inventor and experimenter, surfaced at Aviation Field with two machines: a motor-powered monoplane that he worked on with Warren Eaton; and a man-powered ornithopter, above, an unconventional vehicle reminiscent of technical sketches made by Leonardo DaVinci. Neither the Eaton-Twining monoplane nor the ornithopter left the ground. Of the "flying-bird," Twining wrote, "I could beat the wings some 52 half beats per minute, and . . . [it could] take the wind out [of me] in about 10 seconds." (Above, Library of Congress; right, John Underwood.)

The Jacob H. Klassen family had moved to Los Angeles from Kansas in 1906. He worked as a mechanic, but his tinkering eventually turned him into a serious aviation mechanic and a very fine one at that. He built the unique five-winged multiplane designed by J. S. Zerbe and a unique monoplane for himself, both machines for the Dominguez meet. He also had on the back burner a gyrocopter with four umbrella-shaped vanes. Unfortunately, none of these contraptions flew, but his creativity and modern aeronautical thinking were amazing. (DRAM.)

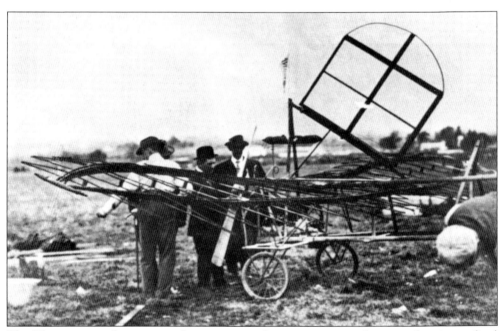

The Klassen monoplane is seen during its initial construction on the grounds prior to final covering with muslin. (TMOF/Hatfield.)

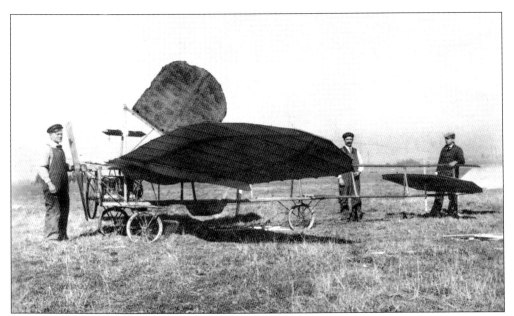

Seen here is the completed Klassen monoplane as it appeared on January 12, 1910. A sketch of this monoplane appeared in the 1910–1911 edition of *Jane's All the World's Aircraft*. Unlike the Wright brothers' Flier design that used wing-warping, Klassen's design had an operable vertical fin, located above the wing near the pilot's seat. This fin was intended to control the plane's banking. (DRAM.)

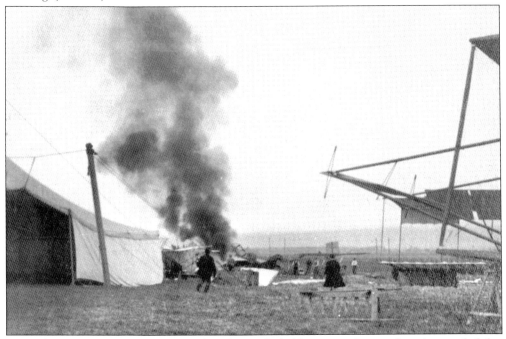

Around noon on January 13, 1910, Jake Klassen fueled his monoplane and inadvertently left a gas can open on the chassis. As he started the engine, a spark ignited the fuel and set the muslin-covered wings of his just-completed monoplane on fire. This stereograph captures Klassen's fiery accident. (CSUDH.)

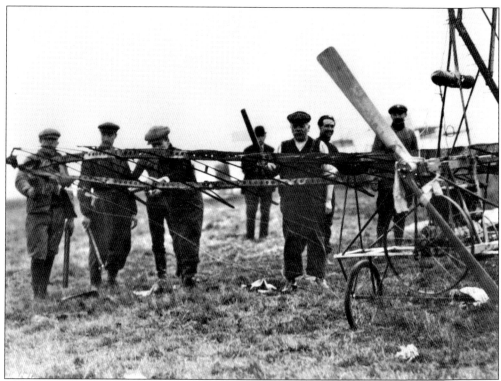

Fire damage eliminated Klassen's monoplane from the competition. He and his workmen clean off the charred portions of the machine before re-covering. (LAPL.)

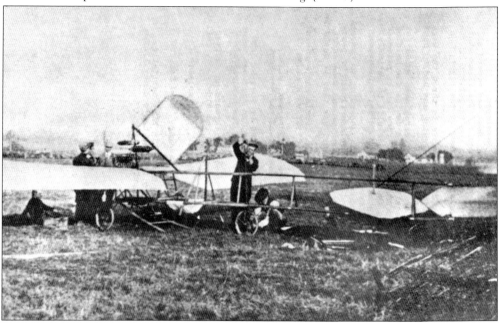

Jake and his monoplane team work frantically to re-cover the charred and cleaned frame with muslin just in time for the Transportation Parade on the last day of the meet. They were determined to complete the work after a week of disaster and frustration. (Hatfield.)

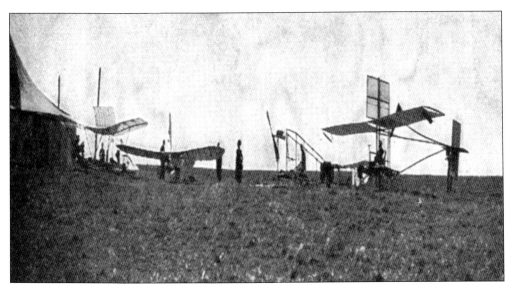

Entrants brought to the meet an assortment of flying machines, many of which were built in backyards, garages, and alleys in Southern California. The airplanes pictured here were being assembled outside along the boundary. Professor Twining remarked during the meet that "there were no more than about five books on the subject of aeronautical science in his high school." These inventions never flew but are a testimony to their creators' ingenuity and were a contribution in spirit to the advancement of aviation science. (Hatfield.)

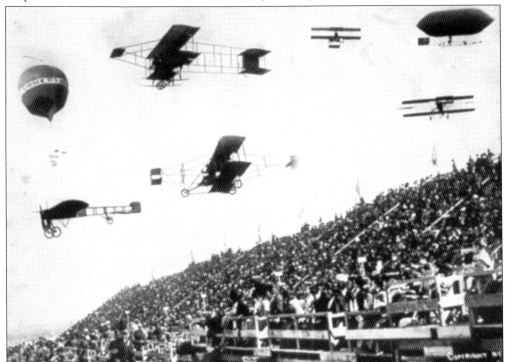

Newspaper photographs teased their readers with an assortment of impossible scenes— fantastic montages of skies filled with flying machines. Darkroom and airbrush magic worked wonders, long before Photoshop software. (Hatfield.)

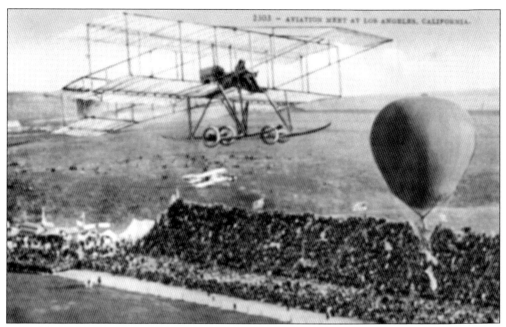

Colorful souvenir postcards of Aviation Week were available. Many were whimsical, as typified by this one. (CSUDH.)

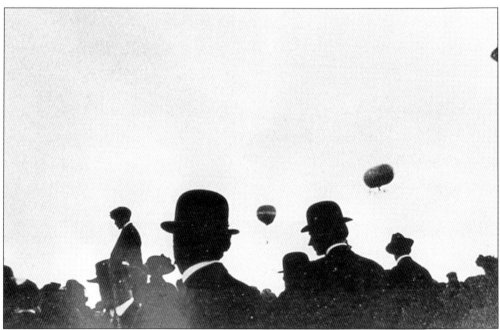

Occasionally spectators could look up and see a large number and variety of aircraft crossing the sky with different sounds and speeds and at varying heights. These bursts of activity thrilled the spectators, whose necks ached and throats became sore from shouting out their approval. (CSUDH.)

LOS ANGELES AVIATION MEET

LOS ANGELES, CALIFORNIA, JANUARY 10 TO 20, 1910

The undersigned, having read the rules and regulations applying thereto, asks entry in Los Angeles Aviation Meet of an aeronef, aerostat, as hereinafter described.

Name _Edgar S. Smith_

Permanent Mail Address _Glendale_

Los Angeles Address _215 W. 16th_

Type of Entry

(left margin, written vertically) WRITTEN WITH LEFT HAND RIGHT HAND INJURED

AERONEF, Make _Own_

Spread of plane or wings _16 ft_ ; width _5 ft_

Weight _190 lbs_ (complete without operator); surface _190 sq ft_

Total dimensions: Width _18 ft_ ; beam _17 ft_ ; height _7 ft with_

Engine: Make _Special_ ; cyls _2 cyl (2 cycle_ h. p. _10 → 15_ ; cooled _air_

propellers _2_ blades; r. p. m. _1000 – 1400_ ; chassis _V trees – co 3 wheel_

Stability _tilting forward planes_ Builder _Edgar S. Smith_

AEROSTAT, Name

Pilot ; aide

Capacity cubic feet; meters; weight (with ordinary equipment) lbs

Fabric of envelope ; built by in 190

Approximate equipment with entry

General Remarks _Please excuse writing, as this was written by left hand, the right being injured by propeller_

Shown here is Edgar S. Smith's Official Entry Registration to the Los Angeles Aviation Meet. Smith arrived early to Aviation Field and quickly assembled his unique tandem monoplane. He swung his propeller through and banged into his writing hand. When registering for the meet, he records this injury on the entry form. The injury was noted by someone—probably not Edgar—in the upper left portion of the form, also. (John Underwood.)

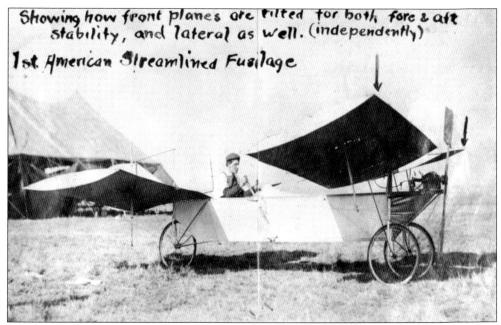

Edgar Smith, a schoolteacher by profession, shows off his tandem monoplane, the *Dragonfly II*, which exhibits some extraordinary aeronautical ideas for the time. There are two sets of two wings (fore and aft) that he calls "planes." He said, "The front planes are tilted for both fore and aft stability, and lateral as well independently." (John Underwood.)

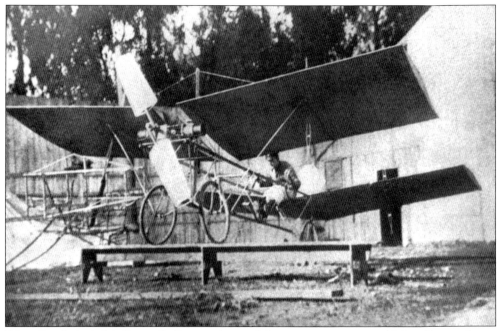

Edgar Smith sits in his *Dragonfly II* monoplane, while executing engine and "plane" control tests while the machine teeters on workbenches. (John Underwood.)

Spectators walking along the route to Aviation Field were bombarded by the shouts of barkers hawking their wares. Memorabilia of all sorts are sold in photograph cards as singles and multiply-folded card sets, sunglasses, buttons, and ribbons. A bestseller was this bright red-on-white banner flag, seen here in replica. (CSUDH.)

It is widely felt that Prof. J. S. Zerbe obtained his idea for his "scalloped-wing" multiplane design from one of his mentors, the famous aviation pioneer Octave Chanute, who in 1896 designed and successfully flew his five-winged glider shown in a sketch here. (Oppel.)

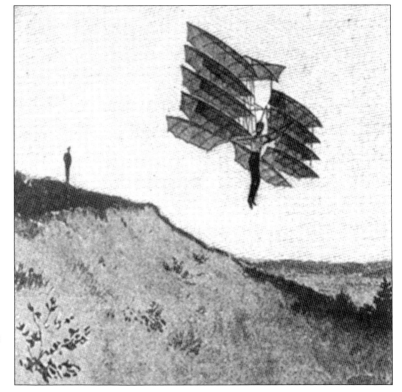

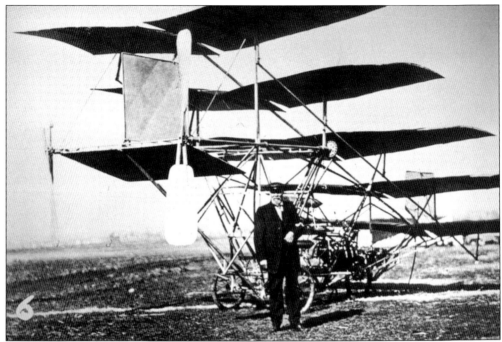

Prof. J. S. Zerbe stands proudly alongside his multiplane. Mechanics towed Zerbe's machine across the field. Edgar Smith's tiny homebuilt followed. Smith had difficulty with his engine and had to be towed back behind the rear of the stands. Zerbe instructed his team to point him into the wind, got inside—apparently without seat belts—and started the engine. (CSUDH.)

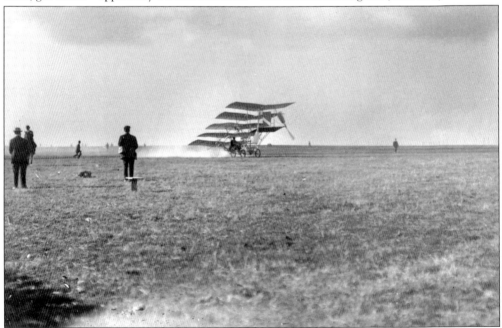

Smoke, dust, and sound are created by his contraption as Professor Zerbe starts his run across the infield. Line judges watch in anticipation of his flight on the second day of competition—Los Angeles Day—at Dominguez Field, January 11, 1910. (LAPL.)

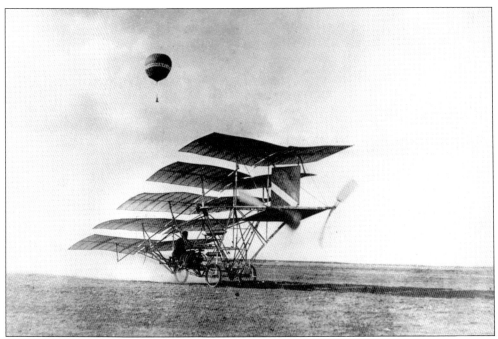

Zerbe's machine (above) continues to emit smoke and dust as it advances in front of the grandstand. Sparks issued from deep inside the contraption as it raced by the crowd. Loud popping sounds like rifle blasts went off across the grandstand. Meet goers were excited and cheering. (Below) As one wheel tried to lift from the ground, the opposite one hit a rut and the whole array plunged to the right, causing all five wings to dig into the ground. Cheers and roars rising from the grandstand turned to laughter as Professor Zerbe was deposited onto the ground. His was a comic ending to what could have been a disaster. (Both, CSUDH.)

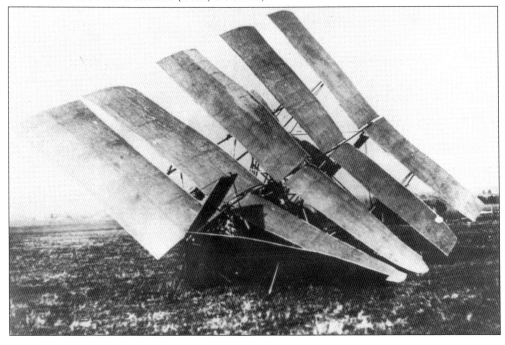

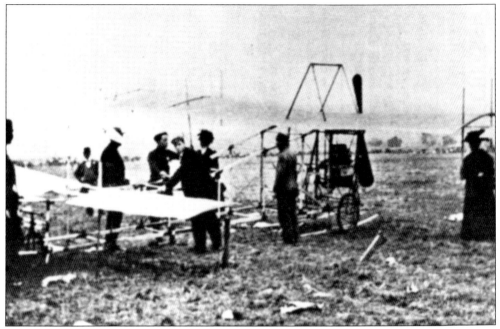

The Eaton-Twining monoplane is worked on frantically all week at Dominguez Hill, but it never makes it to the starting line. It is towed, however, on the final day in the parade of transportation. In front is Edgar Smith's tandem monoplane. (Hatfield.)

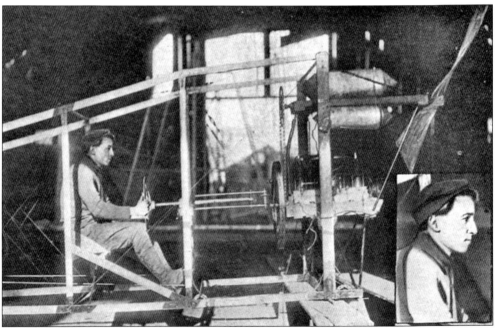

F. Eaton is pictured sitting in a mock-up of the "Bi-Plane Eaton Turning." This is actually the Eaton-Twining monoplane. This was one of 17 views from the popular *Aviation Meet Souvenir Folder of Views*, sold for a price of 15¢. (John Underwood.)

The 1910 meet was a turning point for Lincoln Beachey. While he had attempted, as others did, to build a flyable aeroplane, at the meet he was basically an aeronaut, operating a Knabenshue-built Racing Airship. His older brother, Hillery, had transitioned to heavier-than-air craft by then. Uninitiated and not registered, Hillery still was determined to fly the Gill-Dosh monoplane around Dominguez Hill. He made a few hops and nearly completed one circular flight in the Gill-Dosh Curtiss-type biplane, during which flight after a mile his engine quit, forcing him to land in tough terrain. One landing gear broke, flipping the wing over, and the whole assembly wound up on its nose. After the 1910 meet, Hillery never again operated an airship. (Both, John Underwood.)

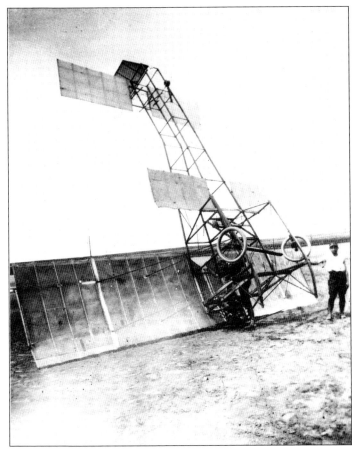

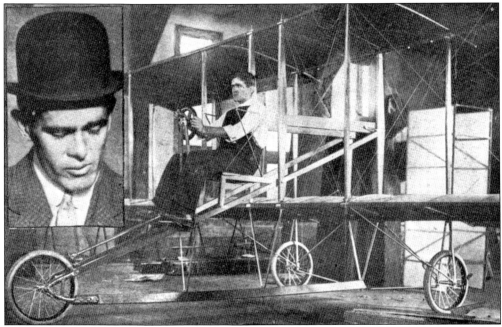

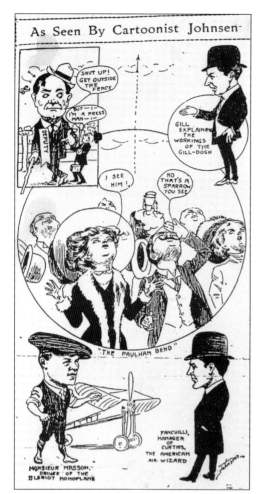

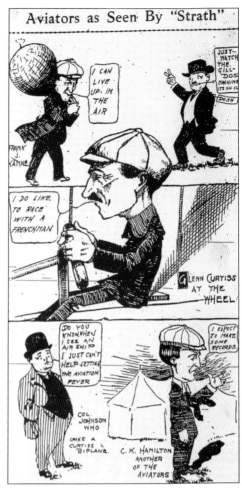

Cartoonists Johnsen and Strath poke fun at spectators and aviators, and at the activities around Aviation Field. (Both, CSUDH.)

Four

AVIATORS AND AERONAUTS FLOCK TO LOS ANGELES

At the Dominguez air meet, a flyer of an airplane was called an aviator. The French used the more descriptive name *pilote-aviateur*. Today the operator of an aircraft is called a pilot, and there is no doubt as to the meaning of the term. In the early 20th century, however, the term "pilot" was reserved for an operator or navigator of watercraft. To avoid confusion in the early 1900s, the distinct name "aviator" was given to pilots of aeroplanes and "aeronaut" to those piloting balloons and dirigibles. These appellations were soon dropped for the common pilot.

Approximately 57 aviation entrants signed up for all forms of air showmanship at Dominguez Hill. Forty-one of them were flyers of a variety of heavier-than-air machines. Only seven actually flew in seven various flying machines in nine competitive events established by the Aviation Committee.

There were 15 entrants called aeronauts in the balloons and dirigibles events. There were 11 balloonists (in 10 balloons), who carried a total of 40 passengers from Huntington Park, the starting terminal or "field." Dirigible race events to San Diego and San Francisco and balloon travel to as far away as the Mississippi River and the Atlantic coast were scheduled. But because of foul weather and prevailing and variable winds, none of these events could take place and only local wanderings were common, including one hair-raising slip out to sea by the balloon *Dick Ferris*. So medallions—no prize money—were awarded to some participating in lighter-than-air machines.

By 1910, dirigibles and balloons, although interesting, were no longer a novelty and did not particularly excite the crowd. At the meet, flyers of dirigibles were Roy Knabenshue, Lincoln Beachey, and Lt. Paul Beck. Flyers of balloons were Clifford Harmon, George Harrison, Frank Kanne, and J. C. Mars.

Aviators and their winged heavier-than-air machines were the big drawing cards. Aviators in attendance who actually flew were Glenn Curtiss, Louis Paulhan, Paulhan's students Didier Masson and Charles Miscarol, Charles Willard, Charles Hamilton, and Col. Frank Johnson. These were the daredevils that the crowd was eager to see.

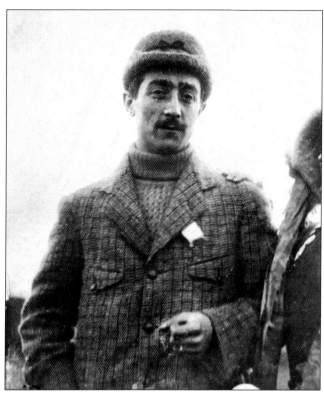

Isidore Auguste Marie Louis Paulhan, known as Louis Paulhan, was born July 20, 1883, in Pénzenas, France. He taught himself to fly in 1909 and became one of the first to receive a French pilot's license. He brought to the Los Angeles air meet an entourage consisting of his wife, Celeste, the family's poodle, the Baron and Baroness de Pennendreff, Didier Masson and Charles Miscarol (his mechanics and flying students), and a few other unnamed mechanics. (LAPL.)

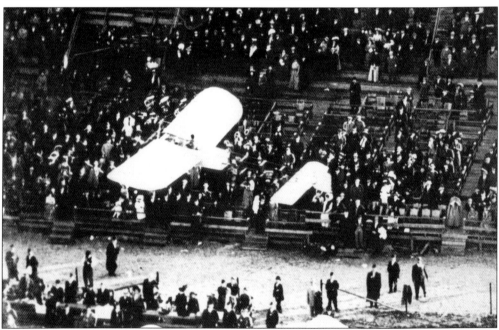

This photograph, obviously a composite, is of a Blériot XI monoplane brought to Los Angeles by the renowned aviator Louis Paulhan. The view supposedly shows Paulhan buzzing the crowd during the meet. The crowd is nonchalant; no one is looking up, and he is only about 50 feet above the ground. (CSUDH.)

Glenn H. Curtiss, an American aviator who was considered on a par with Paulhan, was born in Hammondsport, New York, in 1878 and was known as "G. H." to his friends. Curtiss was a no-nonsense individual. Like the Wright brothers, he started out with a bicycle shop. Later, in order to gain publicity and further his personal interests, he began attaching motors to bicycles, which led to his starting a motorcycle and engine business in 1905. Curtiss became famous after he achieved the unofficial land speed record of 136.3 miles per hour, with a motorcycle of his own design and construction, on January 23, 1907, at Ormond Beach, Florida. He held this record for over seven years. (CSUDH.)

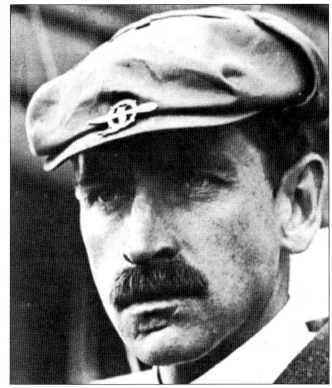

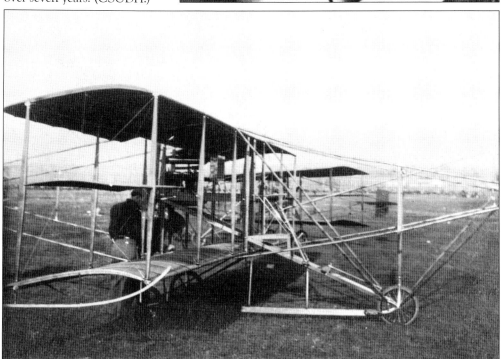

A stereograph shows a freshly assembled Curtiss Flier that was taken out of the tent. This is one of the small Curtiss Fliers brought from Hammondsport, New York. (CSUDH.)

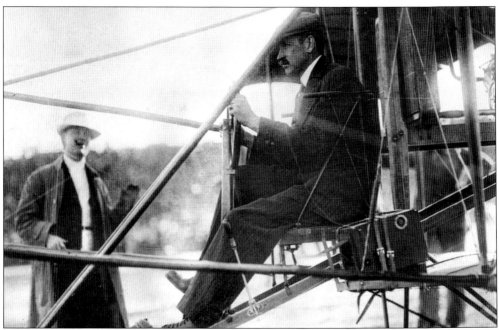

Dominguez aviators occasionally performed activities that were not sanctioned as part of the official program by the Aviation Committee. Curtiss is seen here preparing for a flight, with one of William Randolph Hearst's newspaper cameras attached rigidly to the Curtiss Flier. Aviation Committee chairman Dick Ferris looks on. (CSUDH.)

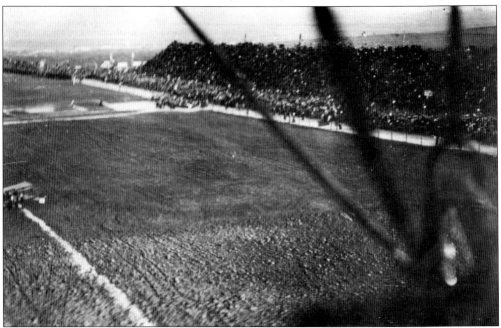

Curtiss has gone aloft in his Curtiss Flier with the Hearst newspaper still camera attached and takes this view while preparing to land in front of the grandstand. Note the unavoidable Flier rigging seen in this picture, possibly one of the very first aerial photographs ever made from a heavier-than-air machine. (LAPL.)

Born in Boston in 1883, Charles Foster Willard (right) was a Harvard graduate and race car driver before entering a diverse aviation career. Charles made his first solo flight on July 30, 1909, at Mineola, Long Island, in his recently purchased Curtiss Model D1 biplane, the *Golden Flier*, the first commercial aeroplane ever sold. Glenn Curtiss—having received Willard's $500 down payment—delivered it to the New York Aeronautical Society in 1909. Willard was the first person Curtiss taught to fly and the fourth American to acquire a license. He became a member of Curtiss's roving flying team and by January 1910 was an accomplished pilot. One of the postcards in an Aviation Meet Souvenir Folder features Charles Willard (below). He is shown landing in his *Golden Flier* and in the inset. (Right, CSUDH; below, John Underwood.)

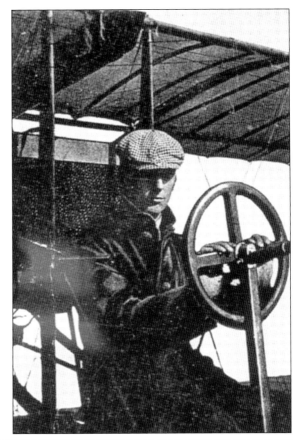

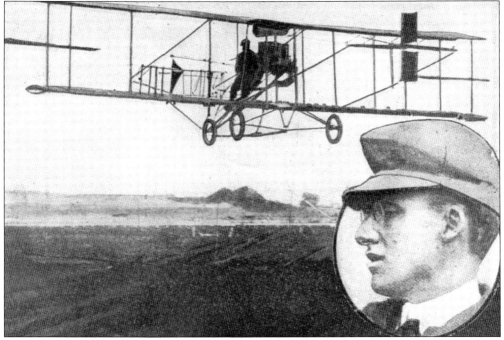

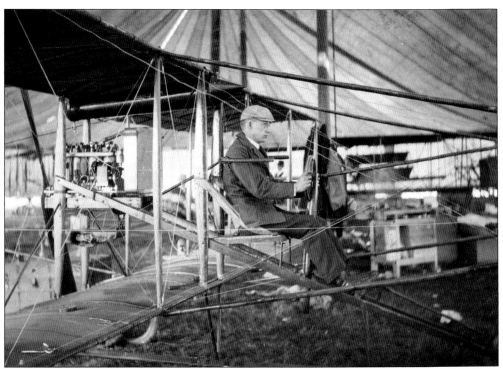

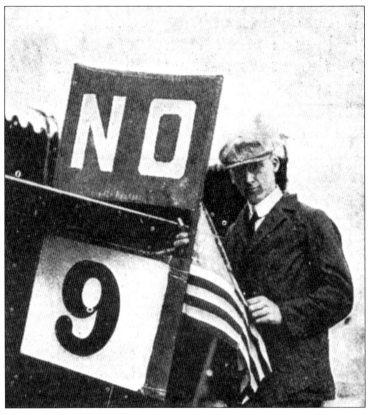

Charles F. Willard is seated in the *Golden Flier* in Curtiss's tent, above. He stands next to the tail section of his Model D1 with competition marking No. 9, below. Both photographs show Willard at the January 1910 Los Angeles Aviation Meet. (Above, USC; left, Oppel.)

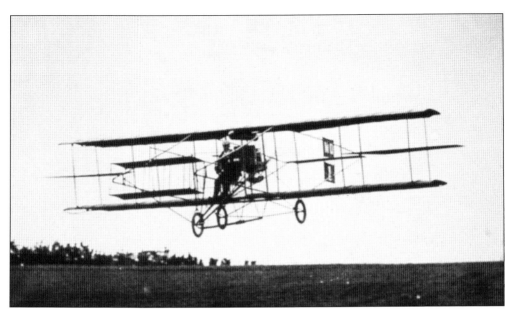

The crowd now saw that Willard was attempting to land within the square. He was short of his goal but jockeyed the throttle, playing with power, and skimmed over the ground. He cut the power again while checking his momentum and glided the Flier 100 feet more. He landed on the same spot from which he had taken off a few minutes earlier. The spectators gave him a rousing cheer for this effort. For this feat, he received an award of $250—the only prize money that Willard and his machine, with its meager 20-horsepower engine, was able to win during the entire meet. This incident was related in Neal and Hatfield (see bibliography). (CSUDH.)

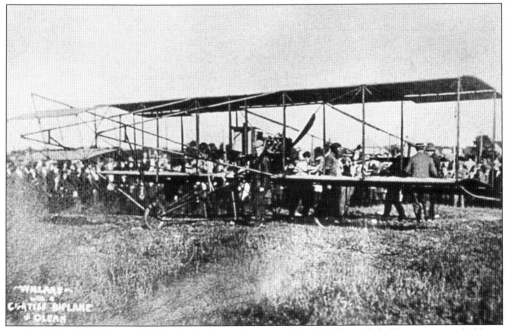

Wherever Willard took the *Golden Flier*, admiring crowds of adults and children surrounded him. Charles stands next to his aircraft as people gather to be photographed with him. Some children do body hangs along the leading edge of his biplane's lower wing. (CSUDH.)

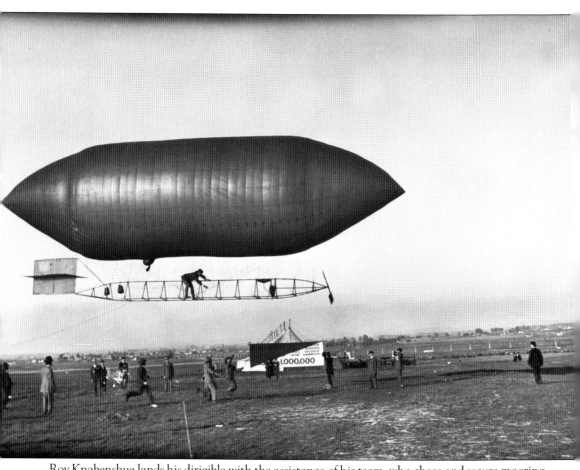

Roy Knabenshue lands his dirigible with the assistance of his team, who chase and secure mooring lines at the January 1910 Dominguez air meet. (National Air and Space Museum, Smithsonian Institution: SI 75-6157.)

Roy Knabenshue promoted several aviation events in his early years and participated in many of them. While "on the circuit" at a St. Louis aviation meet in 1909, he convinced two other well-known aviators, Charles Willard and Glenn Curtiss, to participate in an aviation meet of grand scale on America's West Coast. (John Underwood.)

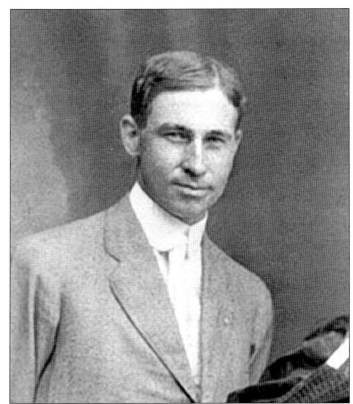

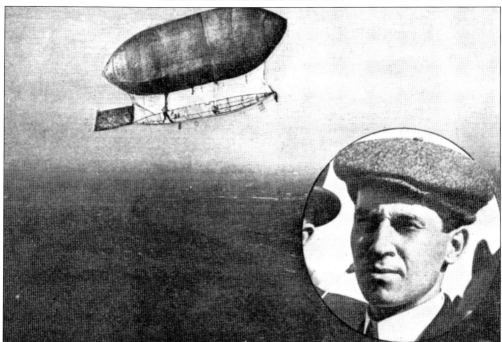

A postcard in an Aviation Meet Souvenir Folder features Roy Knabenshue flying his low and slow 5,500-cubic-feet dirigible. (John Underwood.)

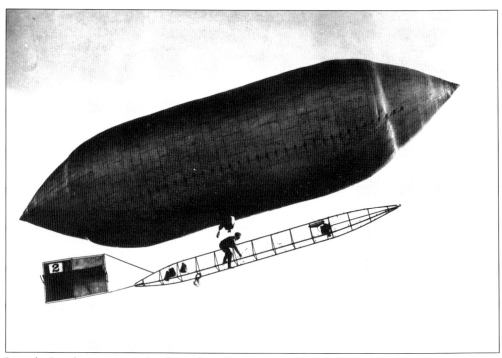

Lincoln Beachey navigates his dirigible at Dominguez Hill in January 1910. He is quite content to fly the slower dirigible racer solo during the meet but has occasional unscheduled racing duels with Roy Knabenshue. (CSUDH.)

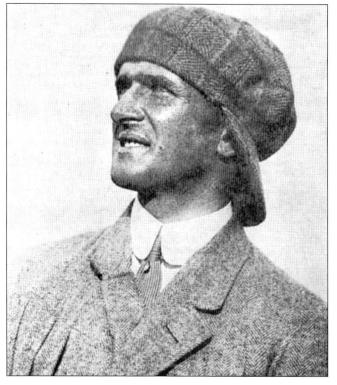

Lincoln Beachey was born in San Francisco on March 3, 1887. He was a prodigy with machines. He started a bicycle shop at age 13, and by age 15, he ran his own motorcycle and engine repair station. At age 17, he made his first powered flight in a dirigible. Seen here at age 19, he was capable of flying balloons and dirigibles in competition and participated in the Dominguez air meet in 1910. (Historical Society of Southern California.)

Born in New Britain, Connecticut, in 1885, Charles Keeney Hamilton became active in hot-air ballooning and parachute jumping at circuses and fairs when he was 18 years old. Three years later, he teamed up with Roy Knabenshue and began piloting dirigibles. He then learned to fly airplanes under Glenn Curtiss in late 1909 and soon became one of the best known American flyers of that time. Known as a daredevil pilot who would fly anything anywhere, Hamilton repeatedly crashed his *Hamiltonian*, a rogue biplane with an eight-cylinder, 110-horsepower motorcar Christie engine that colleagues termed "too hot to handle." (Hatfield.)

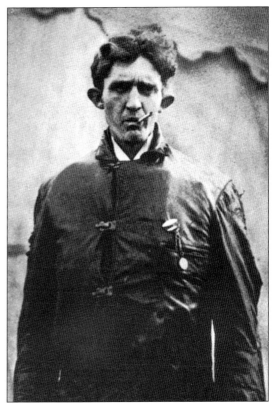

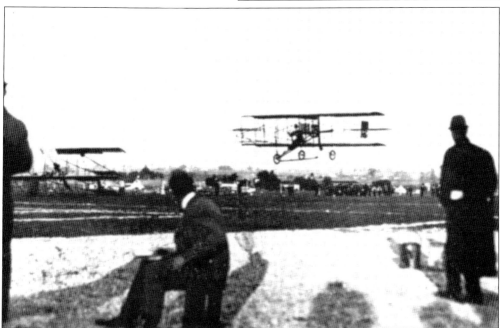

On January 12, 1910, at Dominguez Hill, Hamilton lands prematurely after attempting an endurance record. He was able to make only one trip around the course because of engine malfunction. (Hatfield.)

On the sixth day, January 15, San Francisco Day, Charles Miscarol took one of the butterfly-shaped Blériot XI monoplanes out of Paulhan's tent to test the engine. Lateral control was disabled on this machine, as Paulhan did not want anyone to think that he was violating the Wrights' patent on wing warping. Miscarol took off and had trouble from the beginning with steerage. The plane veered from right to left, and suddenly the left wing struck the ground. Charles was thrown forward and hit his head on a truss-rod atop the machine. Dazed, he leaped from the machine and began running across a barley field, when a Los Angeles *Herald* reporter who happened to be the only one nearby asked him if he was wounded. Miscarol stopped, putting his hand to his forehead, and said in French, "Me? What the devil has happened?" He thought he had been pitched out and had fallen from a great height but soon came to realize that he had only suffered a bruise on his forehead and was otherwise unhurt. This incident was related in Field and Hatfield (see bibliography). (CSUDH.)

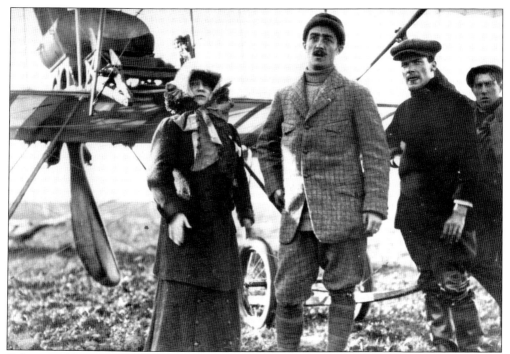

Celeste Paulhan, Louis Paulhan, his student Didier Masson, and an unidentified mechanic pose in front of the standard Farman biplane. Paulhan and his warmly dressed wife prepare for their cross-country trip to Redondo Beach. (LAPL.)

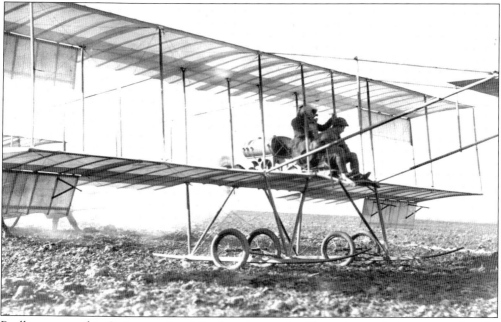

Paulhan revs up his Gnôme engine. His plane is restrained by assistants during preparations for takeoff to Redondo Beach. Accompanying Paulhan on this cross-country flight is his wife, Celeste, who holds on for dear life. The couple travels out over the water and returns. It is a 21.25-mile excursion in which he achieved a world record. (CSUDH.)

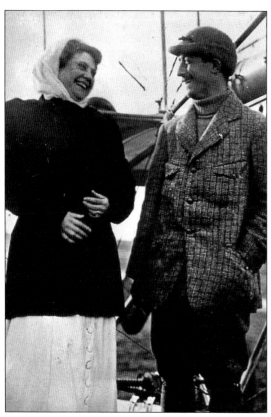

Louis Paulhan chats with Florence Stone (Mrs. Dick Ferris) just before the two climb aboard the standard Farman II biplane for a trip around the circuit. (CSUDH.)

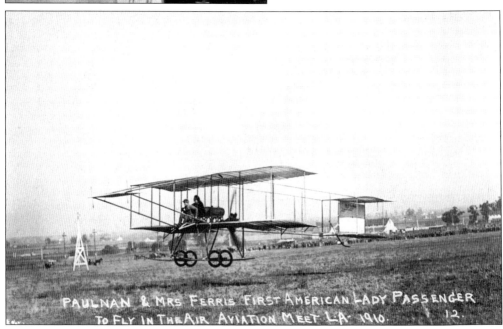

PAULNAN & MRS FERRIS FIRST AMERICAN LADY PASSENGER TO FLY IN THE AIR AVIATION MEET L.A. 1910. 12

At this meet, Mrs. Ferris is the first American woman passenger to be taken up by Paulhan in his standard Farman II biplane at the 1910 Los Angeles Aviation Meet. This postcard shows them in a smooth takeoff. (CSUDH.)

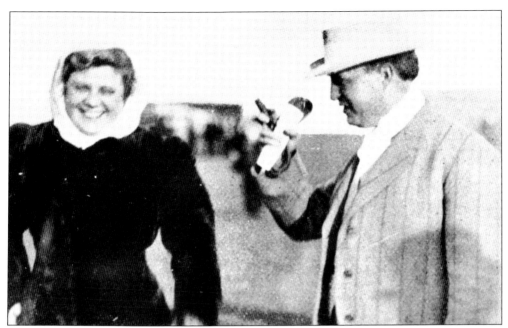

Dominguez air meet promoter Dick Ferris asks his wife, the stage star and singer Florence Stone, "Now, tell me really, how was that ride with Louis Paulhan?" (Out West.)

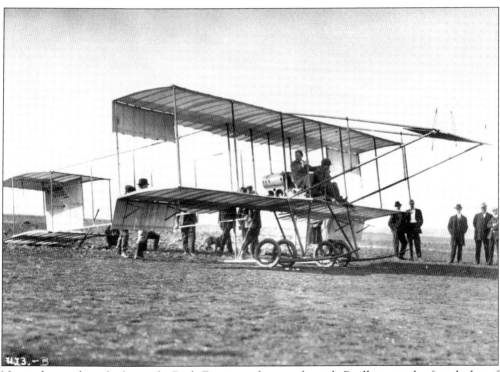

Not to be outdone by his wife, Dick Ferris catches a ride with Paulhan on the fourth day of competition. Paulhan achieves another record of sorts in ferrying a total of eight people on this day. (CSUDH.)

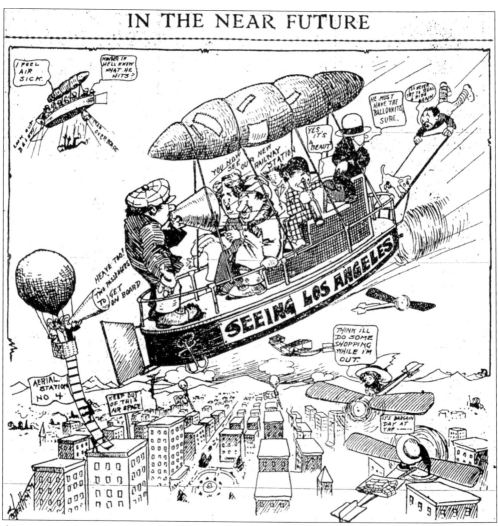

Air passenger trips made at the Dominguez air meet made an impression on Angelenos. A cartoonist from the Los Angeles *Express*, January 8, 1910, provides a humorous look at the public's bent for future air travel over Los Angeles via balloons and airplanes. Air transportation will apparently be for sightseeing and shopping. There are perils, however, of air travel: air sickness, falling overboard, and aviation stowaways. Every one of these—and of course parking—was seen as a future hazard. (CSUDH.)

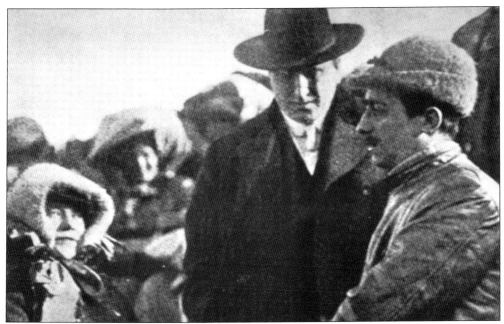

William Randolph Hearst speaks with Louis Paulhan and his wife, Celeste, before Hearst's first flight with Paulhan. (Hatfield.)

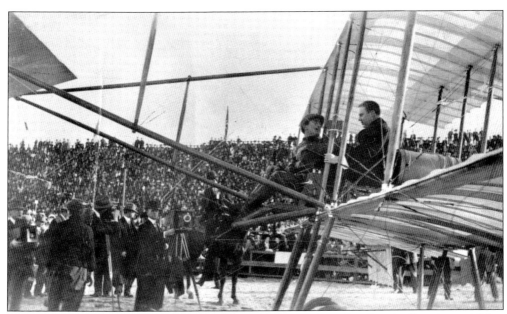

Among the seven passengers that Paulhan flew on January 19 was Los Angeles *Examiner* publisher William Randolph Hearst, who wrote his own account of the trip. Seen here is Paulhan preparing for flight with a passenger who is often identified as Hearst, but there is some doubt that it is the publisher. (CSUDH.)

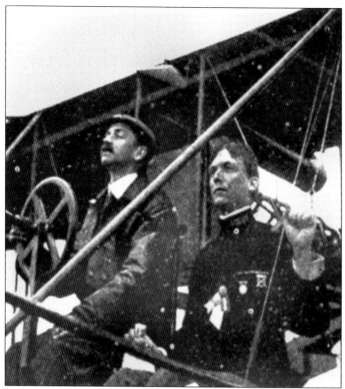

On the fifth day, Friday, January 14, Southern California Day, Lt. Paul Beck flew as a passenger with Glenn Curtiss. Beck brought a few bags of dirt to use as "bombs" for target practice to test the aeroplane's potential as a military device. Unfortunately, engine failure cut short this experiment. Five days later, on January 19, Louis Paulhan and Lieutenant Beck dropped three 2-pound sandbags to hit a ground target. This accomplished, Lieutenant Beck was the first army officer to complete a simulated bomb drop experiment. This incident was related in Frank Oppel's *Early Flight: From Balloons to Biplanes*. (Beck.)

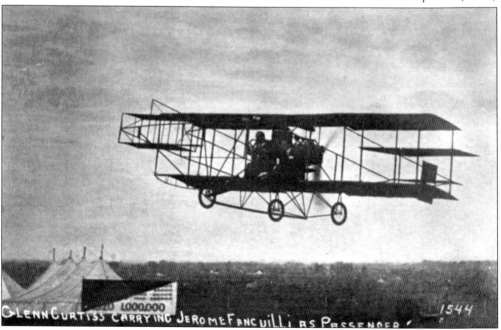

In one of the Aviation Meet Souvenir Folders, a postcard shows Glenn Curtiss carrying Jerome S. Fanciulli, general manager of his Curtiss Exhibition Company, as a passenger at the Dominguez Air Show. Fanciulli was also a member of the Dominguez air meet's Aviation Committee. (John Underwood.)

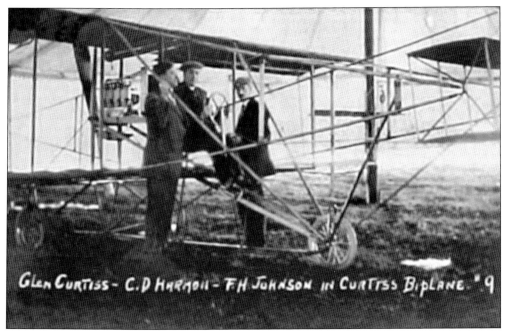

This postcard shows a meeting around the rigging of C. B. Harmon's Curtiss Flier–type biplane. From left to right are D. J. Johnson, Clifford B. Harmon, and Glenn H. Curtiss. Harmon purchased this plane from Curtiss in 1909. (CSUDH.)

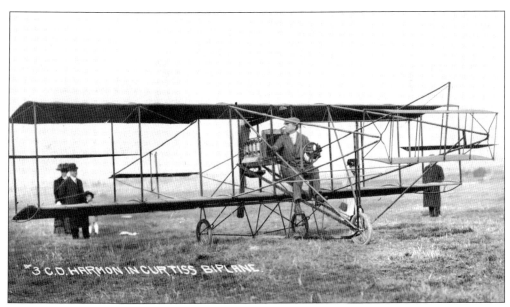

Millionaire Clifford B. Harmon sits in his Curtiss Flier. By 1910, he was equally adept at flying in balloons and biplanes, especially the small Curtiss Flier. Later that year, Harmon became a member of the Aero Club of America (ACA) and flew the large Farman with Gnôme engine. Harmon was the sixth aviator to obtain a pilot's license under ACA jurisdiction. By 1926, he became a wealthy sportsman and aviator and established three International Harmon Trophies, awarded annually to the world's outstanding aviator, aviatrix, and aeronaut. (CSUDH.)

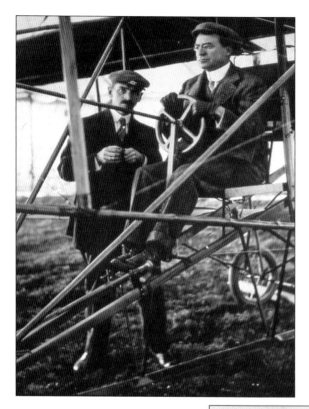

Glenn Curtiss (standing on the left) and Curtiss flying team member Clifford Harmon (seated in his Curtiss Flier) are shown. (CSUDH.)

Clifford Harmon (standing) and C. H. Johnson (seated) pose for this photograph. Curtiss, Harmon, and Johnson were often photographed together in order to advertise Curtiss-built aeroplanes and engines. The Wright brothers warned that this kind of commercialism would take place at the January 1910 Dominguez air meet. (CSUDH.)

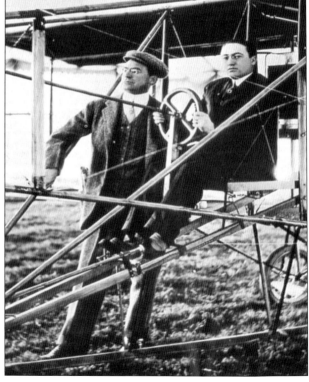

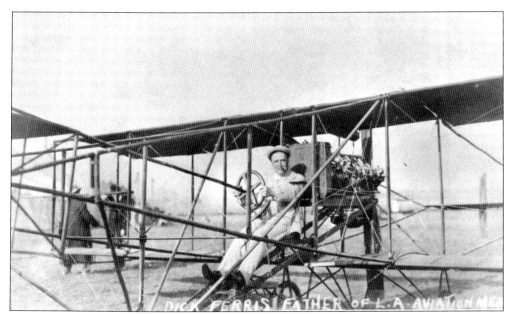

Always the promoter, Dick Ferris takes the pilot's seat as if it were his own. Fortunately, the Curtiss Rheims Racer with V-8 water-cooled, 50-horsepower engine did not move from this spot until the chairman of the Aviation Committee—also known as the father of the Los Angeles International Aviation Meet—had left. (CSUDH.)

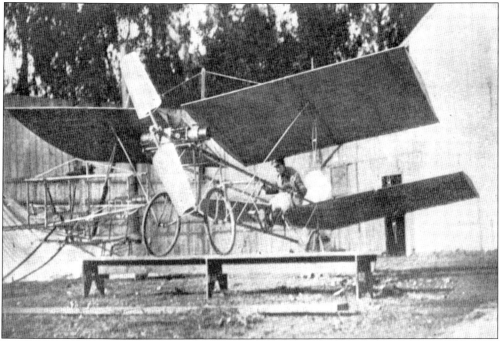

Here is another look at Edgar Smith in his tandem monoplane, the *Dragonfly II*. He officially entered the competition and was eager to win with his creative design. Unfortunately, his injuries from propeller blows on his right hand and head kept him from flying in the meet. (John Underwood.)

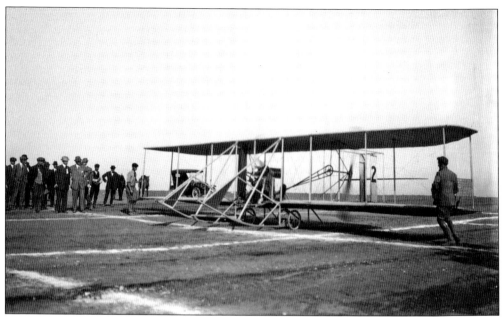

In addition to being one of America's most accomplished lighter-than-air pilots, Roy Knabenshue also learned to fly heavier-than-air machines. In 1909, after several years of barnstorming, he became the general manager for the Wright Brothers flying team. He brought a Model B Wright Flier (seen here) to Dominguez Hill to display its versatility. (CSUDH.)

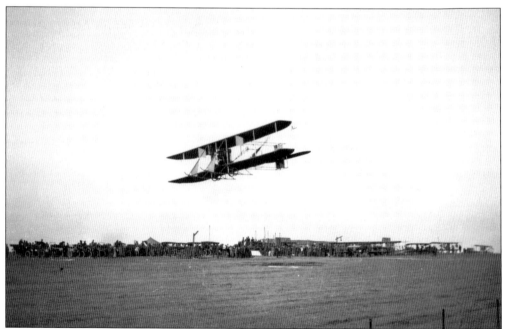

Another Wright Model B biplane flies over an unidentified field at what appears to be a fly-in. This is not the Dominguez air meet. Like many other post-Dominguez air meets, aviation became extremely exciting and important. It is interesting to speculate how different those early international aviation meets would have been if the Wright brothers had participated. (CSUDH.)

Five

AËROPLANES, DIRIGIBLES, AND BALLOONS

Balloons, dirigibles, and aëroplanes—a wondrous assortment of flying machines—arrived at Dominguez Hill. Balloons had been around for a quarter of a century and dirigibles for about five years. These lighter-than-air vehicles had already proven themselves to be flyable, reliable, and safe, though a slow means of transportation. Then came the aeroplanes of European and American design: Blériot monoplanes, Farman biplanes, Curtiss biplanes, a Gill-Dosh monoplane from Baltimore, Edgar Smith's tandem monoplane, Eaton-Twining's and Klassen's monoplanes, plus a host of other air vehicles. These heavier-than-air flying machines were exciting, new, and in some cases not yet proven.

The aviation mechanics and their behind-the-scenes activities at the air meet were only briefly described in the historical accounts of J. Wesley Neal and D. D. Hatfield. Images of the bustling activities in Paulhan's and Curtiss's tents during Aviation Week have never been published until now. Contained in a set of stereographs, the images were made available to this author by the Archives/Special Collections Library at California State University at Dominguez Hills, for the centennial celebration of 2010. But of course, only one side of the stereograph image is shown.

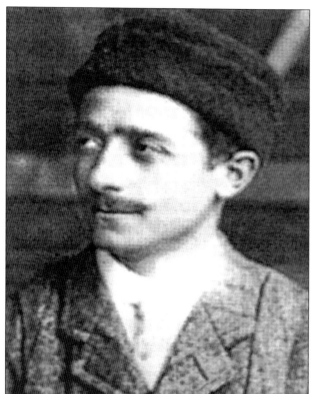

Louis Paulhan was short and slight of frame, weighing perhaps 140 pounds, brimming with nervous energy and perfectly in control. He was imaginative and daring. He announced beforehand what he would do, and his execution always surpassed his plans. (Hill Air Force Base Aviation Museum.)

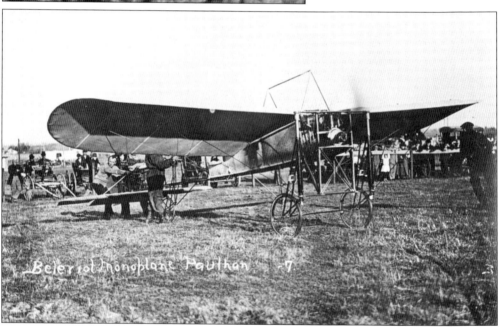

Beleriot monoplane Paulhan -7

This postcard shows a typical start for Paulhan and his Blériot monoplane. Team members hold back the vibrating monoplane while the engine is revving. Paulhan took a seat slightly forward of mid-ship—there were no cockpits yet—and with a hand signal, the machine was released and he was jettisoned forward for the takeoff. (John Underwood.)

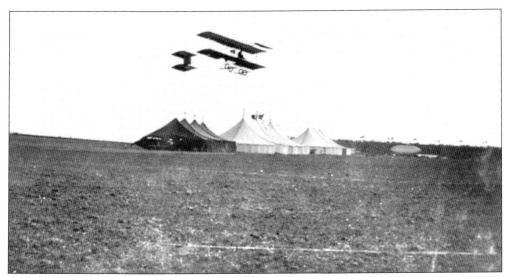

Large tents for dirigibles and smaller tents for airplanes were set up in the infield. Front row tents in front of the grandstand were reserved for the flying teams of Paulhan, Curtiss, Knabenshue, and Beachey. Lesser-known aviators and their machines were relegated to tents behind the grandstand; others did not have any tents. In the foreground, Paulhan's Farman plane flies low over the field. In the distance, mechanics can be seen assembling their machines under the tents. (CSUDH.)

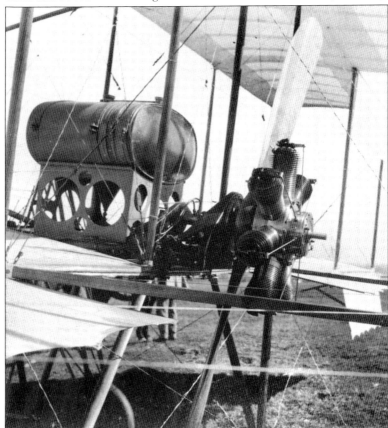

This stereograph shows the activity under Paulhan's tent. His standard Farman is being prepared for flight. The air-cooled, seven-cylinder, 50-horsepower Gnôme engine with its 8.5-foot-diameter propeller and large 490-pound capacity fuel tank (about 82 gallons)—the world's largest to date—distinguishes this model from the smaller model Farman. Out of the crate, it looks clean and new. (CSUDH.)

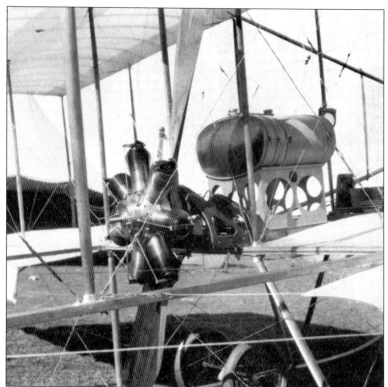

This stereograph shows, from a different angle, the large Farman being assembled under Paulhan's tent. The French brought modern examples of their aeronautical sciences. They knew the benefit of lightweight construction. They made lightening holes for weight reduction in their gas tank support structures and used an efficient combination of laminated wood and metal tubular frame construction. (CSUDH.)

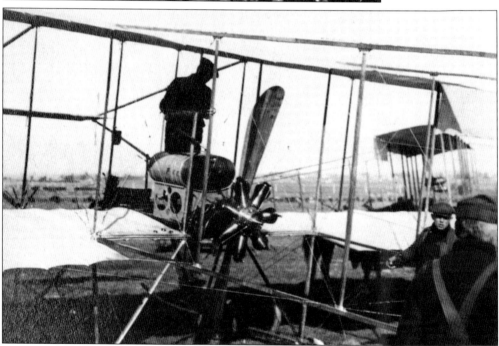

After taking the plane out from under the tent and into the sun, Paulhan's mechanics string cabling and other harnessing hardware to complete assembly of the standard Farman biplane. (CSUDH.)

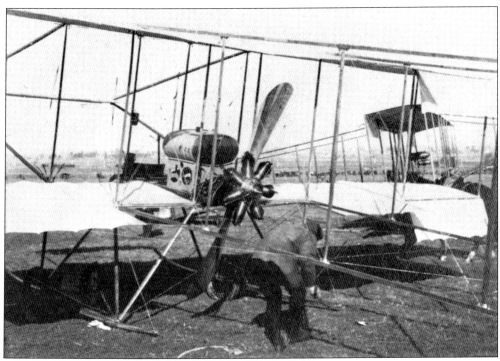

Outside the tent, one of Paulhan's mechanics works on an important portion of the fuselage framework. (CSUDH.)

Under Paulhan's tent, a mechanic makes adjustments to the smaller Farman biplane. It had a 38 horsepower Gnôme air-cooled engine, a smaller gravity-fed fuel tank than the standard Farman, and an empennage (tail section) that looks like a box-kite—a carryover from Paulhan's earlier Rheims Voisin biplane. (CSUDH.)

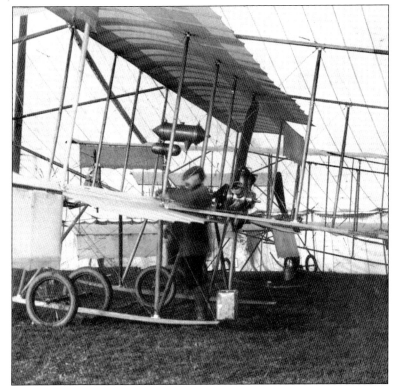

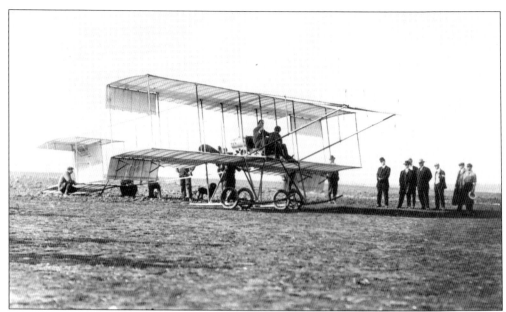

After the mechanics have finished their work on the large Farman, they tow it to the field where Louis Paulhan and promoter Dick Ferris rev the Gnôme engine, readying it for a short joyride. Onlookers stand beside the Farman while team members hold the machine back. (DRAM.)

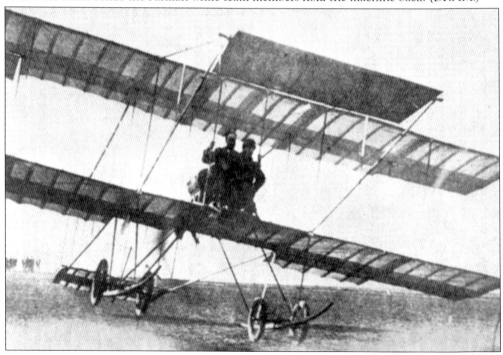

After release, the Farman carrying Paulhan and Dick Ferris takes off at Dominguez on the fourth day of the air meet, Thursday, January 13. Paulhan is flying the larger Farman biplane, which has the single vertical stabilizer and 490-pound capacity fuel tank. A gust from the side or tail nearly lifts the plane off the ground. On this day, Paulhan made eight passenger flights in two hours. (CSUDH.)

The following is an ode to Glenn H. Curtiss, who is celebrated for his feats on a motorcycle and in his *Gold Bug*: "If on a balmy summer eve / You ever chance to spy / A bug of most unusual size / Above you in the sky, / Don't be afraid, and shut the doors / And all the windows tight, / It's nothing but the Gold Bug out / To take a spin by night. // Glenn Curtiss can't be beaten in / A motor-cycle race, / A score of trophies he displays / To show he set the pace, / But since he hatched the Gold Bug, lo! / It is his pet and pride, / And he delights upon its back / To take a rapid ride." This anonymous poem together with the cartoon on the right was printed in the August 1909 *Aeronautics* magazine (page 40). (CSUDH.)

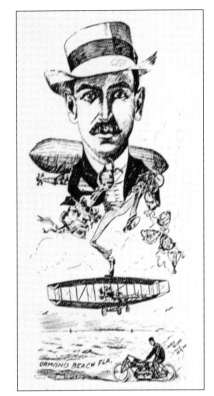

Below, this stereograph shows the tent assigned to Glenn Curtiss's team. It is probably Glenn Curtiss who is seen standing on the lower wing of the Rheims Racer, peering over his V-8 engine, while an unidentified team member stands and works alongside the fuselage. (CSUDH.)

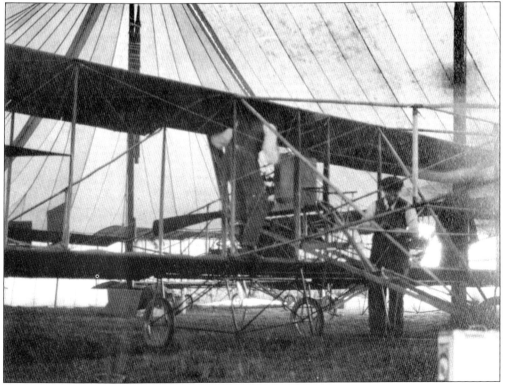

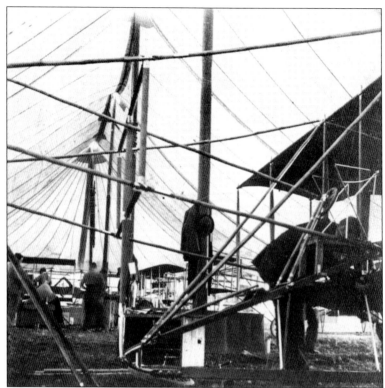

Clearly seen in this stereograph are two mechanics from Glenn Curtiss's team who are working in the tent at their respective stations. Curtiss brought three Curtiss Fliers and one Rheims-type Racer with him from Hammondsport, New York. The day before the meet began, there was a flurry of activity. (CSUDH.)

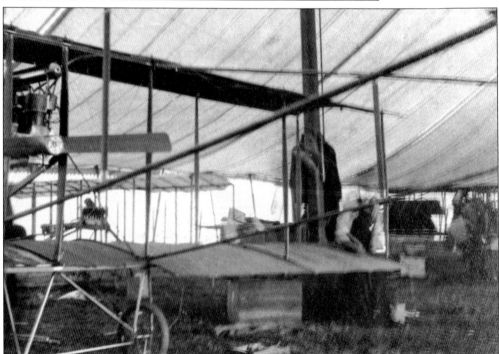

In this stereograph, a few workers under the tent put the finishing touches on two Curtiss Fliers. (CSUDH.)

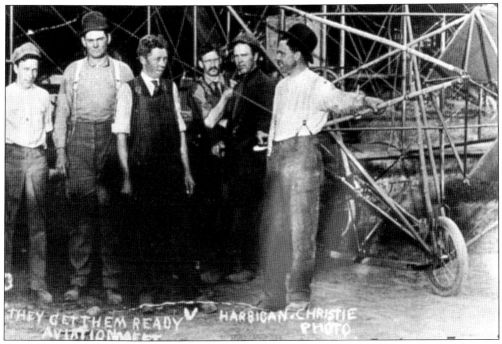

This postcard, captioned, "They Get Them Ready—Aviation Meet," shows a team of young aviation mechanics taking a break for a photo shoot before returning to work. (CSUDH.)

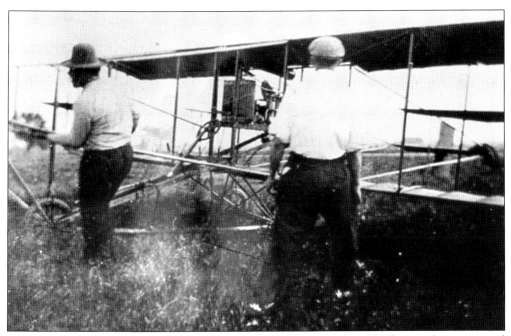

Two workmen drag Curtiss's plane through some weeds in a rough field. This may have occurred after one of Curtiss's flights, abbreviated by engine failure, forced him to land prematurely in the back of Aviation Field. The size of the radiator indicates that it is one of the smaller Curtiss Fliers. (CSUDH.)

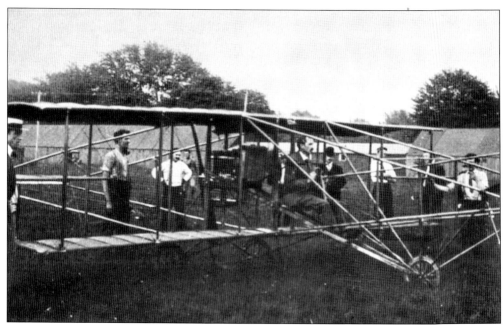

Curtiss is the pilot in the seat of his small Flier, with several of his team members standing around. The trees and sheds in the background suggest that the place is not Dominguez Hill. (CSUDH.)

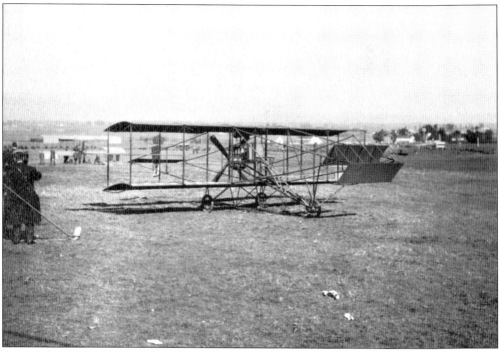

One of the Curtiss D1 models with a four-cylinder engine and four propellers sits ready for its pilot. This was Charles K. Hamilton's Flier. Hamilton flew this model in an attempt to set an endurance record. (CSUDH.)

In 1905, Glenn incorporated his G. H. Curtiss Manufacturing Company. With this humble start, Curtiss began his airplane and engine manufacturing company in Hammondsport, New York. An accomplished inventor and designer, Glenn was well known for testing all of his aviation designs with his so-called "wind wagons," seen here. These small contraptions permitted him to test motors, propellers, controls, and surfaces. In this experiment, Curtiss is about to use a "wagon" to test an elevator design common in many of his early Flier or D1 machines. (National Air and Space Museum, Smithsonian Institution: SI 87-6027.)

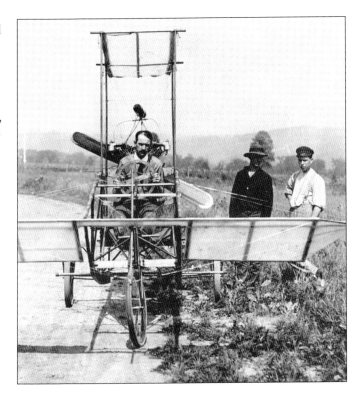

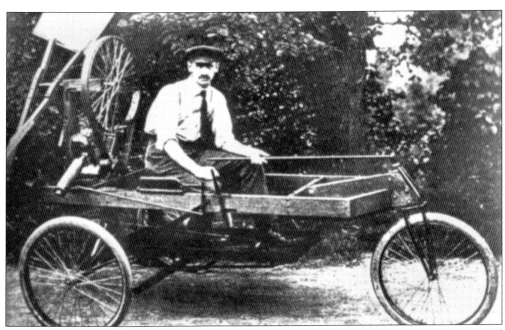

Curtiss continues to experiment and test with his wind wagons. He poses here with the second of his three wind wagons. In this instance, he appears to be testing trailing surface controls and possibly an engine. (CSUDH.)

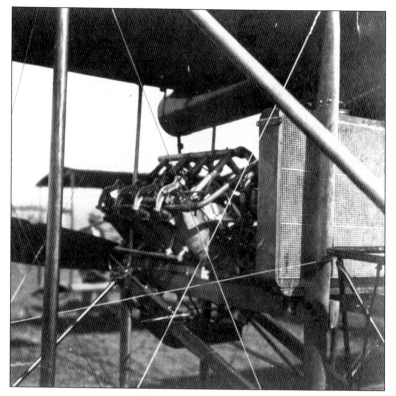

This stereograph view shows the progress being made in assembling Curtiss's Rheims Racer after the radiator and V-8 engine have been installed. (CSUDH.)

This stereograph shows an unidentified Curtiss team member standing alongside the Rheims Racer, which has been taken outside in the sun. Spectators from the stands jockeyed to various vantage points in an attempt to get a glimpse of the activities going on inside their favorite team's tent. As soon as most of the machines were assembled, owners/ aviators would take them outside for final adjustments, much to the delight of the crowd. (CSUDH.)

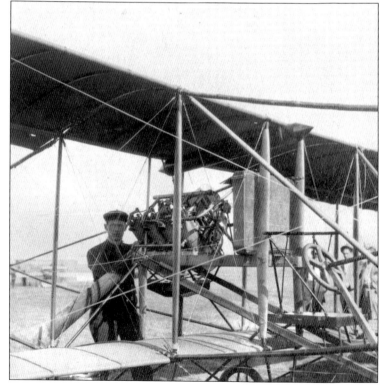

This stereograph is a photograph of the Curtiss Racer brought back under the tent, receiving some last-minute tweaking of the muslin covering on the bottom wing. It is likely that it is Curtiss himself who is making this repair or adjustment, as the workers on the team would be wearing T-shirts or coveralls. (CSUDH.)

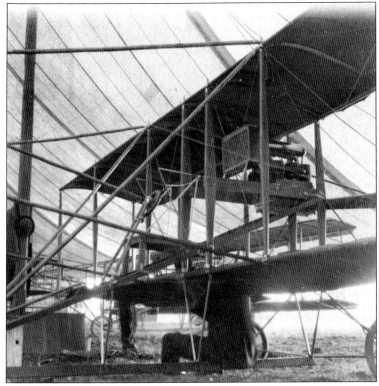

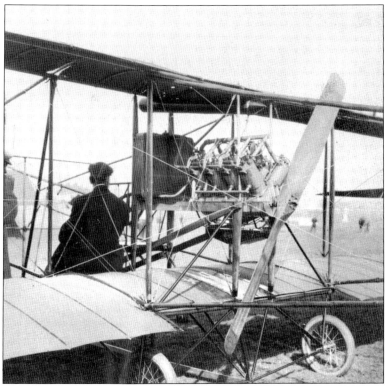

This stereograph shows the Racer back outside in the sun after final adjustments were made. It is most likely Curtiss, with his back to the camera, leaning against the leading edge of his machine. This view shows the opposite side of the wing of the biplane seen at the bottom of page 88. (CSUDH.)

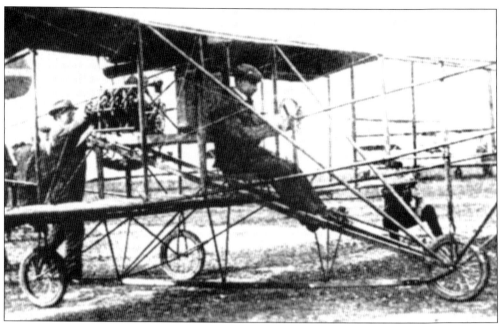

Seated in his Rheims Racer, Curtiss awaits propping and anticipates the rush of air and the blast of noise that will emanate from the 50-horsepower engine. His team members hold on to the wings and tail section and await his signal to release for takeoff. (CSUDH.)

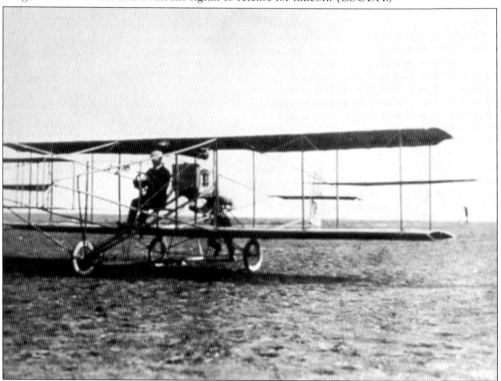

Charles F. Willard, seated in his *Golden Flier*, gets an assisted push as he attempts to taxi across the muddy field at Dominguez Hill. (CSUDH.)

Willard sits on his Curtiss *Golden Flier* (Model D1) that he brought to the January 1910 Dominguez air meet. Willard was Curtiss's first flying student and became an expert flyer, occasionally beating Curtiss in air duels. (CSUDH.)

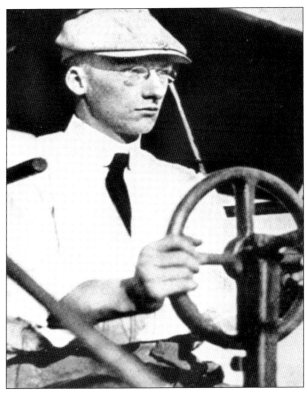

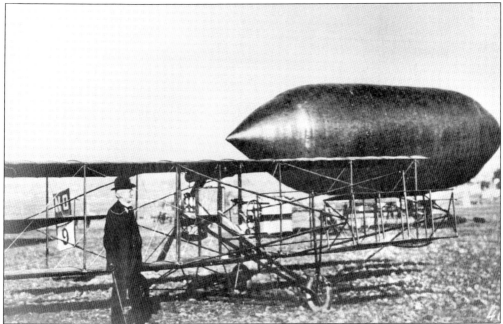

Other aviation vehicles at Dominguez Hill were balloons and dirigibles. Almost everyone knew about their early history and capabilities. The advance of air transportation from lighter-than-air to heavier-than-air machines is clearly evident in this image of Roy Knabenshue's streamlined dirigible as a backdrop to Charles F. Willard's *Golden Flier*. (CSUDH.)

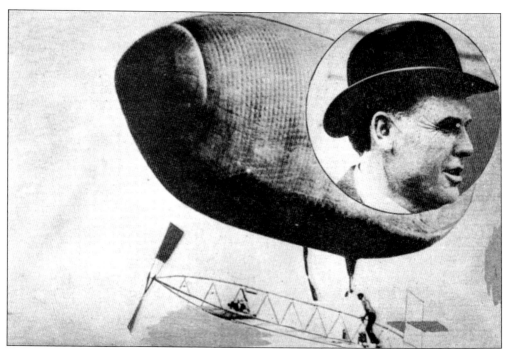

In 1900, Thomas Scott Baldwin created a motorized balloon. Using a motorcycle engine built by Glenn H. Curtiss and an aerodynamic cigar-shaped, hydrogen-filled balloon, Baldwin created the dirigible *California Arrow*, which underwent the first controlled circular flight in America on August 3, 1904. The aircraft was piloted by Roy Knabenshue at the 1904 Louisiana Purchase Exposition in St. Louis. Knabenshue also flew Baldwin's dirigible in New York City in 1905. (John Underwood.)

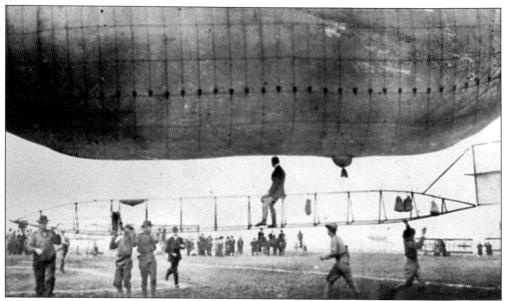

Roy Knabenshue is seen standing on the rails of the dirigible *California Arrow*. He is preparing for takeoff in New York City on August 20, 1905, for a tour over downtown skyscrapers. (John Underwood.)

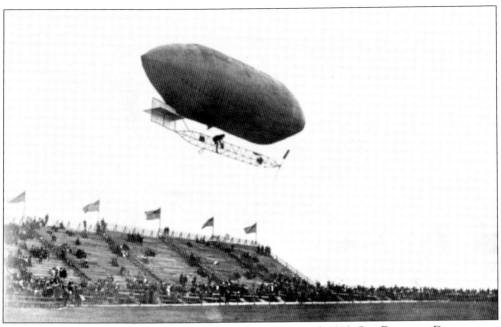

On the cold and windy late afternoon of Saturday, January 15, 1910, San Francisco Day, a sparse audience, sitting at the west end of the grandstand, watches Roy Knabenshue drive his dirigible into the wind. (CSUDH.)

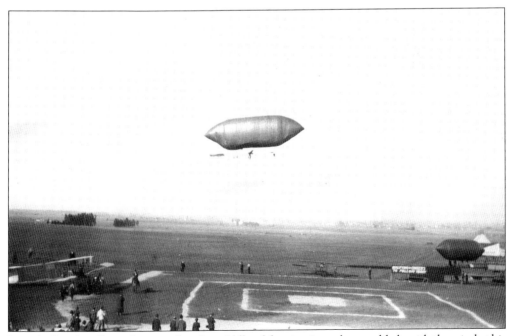

Lincoln Beachey floats downwind in the middle of the circuit track, most likely with the wind at his back, and pulls the power back, beginning his slow, silent descent to the ground. (CSUDH.)

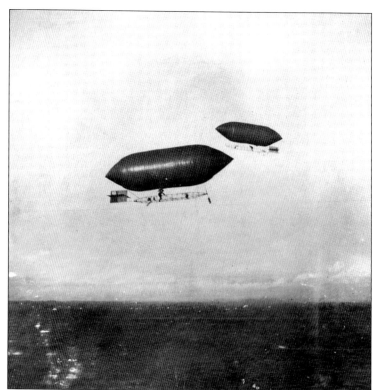

Unofficial dirigible races between Lincoln Beachey and Roy Knabenshue happened from time to time. The "races" usually took place when airplane activity was at a lull. They entertained the crowd and brought some well-deserved attention to the aeronauts, who did not receive any prize money for dirigible flights. (DRAM.)

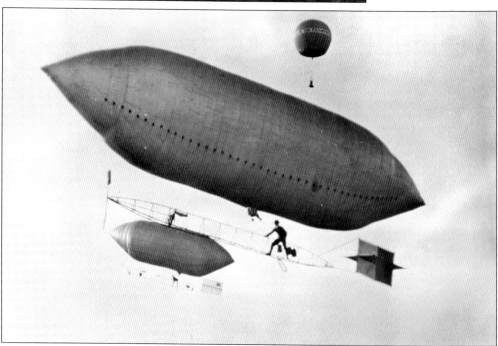

One of the most famous photographs taken at the 1910 air meet was this one attributed to C. C. Pierce. Knabenshue (near side) and Beachey (far side) are beneath the tethered balloon *Examiner*, beating against a west wind. (John Underwood.)

A postcard from an Aviation Meet Souvenir Folder shows the 80,000-cubic-foot *New York* with owner/aeronaut Charles B. Harmon, his aide George B. Harrison, and four passengers on board. On Monday, January 10, the *New York* made its first ascent from the balloon field at Huntington Park. Southerly winds drifted it northwest as far as Colegrove, only 12 miles away. On that same day, the *Peoria*, piloted by Frank J. Kanne and J. C. Mars, followed the *New York* and also landed at Colegrove. (Colegrove, south of Hollywood near today's Hancock Park, was annexed to Los Angeles on October 19, 1909.) (John Underwood.)

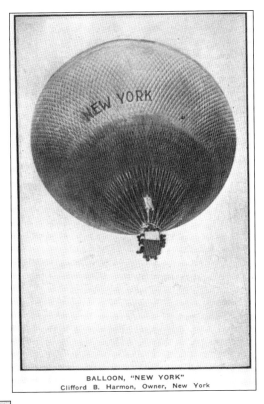

BALLOON, "NEW YORK"
Clifford B. Harmon, Owner, New York

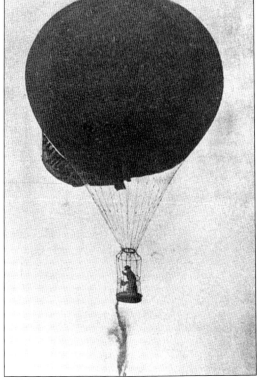

Another postcard from an Aviation Meet Souvenir Folder shows the balloon owned by the Aeronautical Squad of Company A, Signal Corps, National Guard of California (NGC). Aeronaut Charles D. Colby pours sand ballast overboard for vertical lift assist. At one point, the balloon lost much gas and sat on a field with less than one-third of its required amount of hydrogen pumped in. For the large NGC balloon and for Lt. Paul Beck's government 20,000-cubic-foot dirigible, the hydrogen facilities at balloon field were insufficient. (John Underwood.)

95

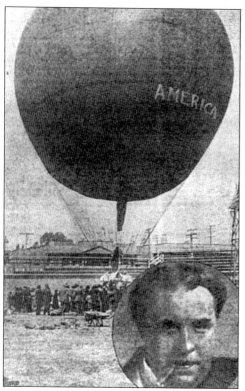

This postcard from an Aviation Meet Souvenir Folder shows the balloon *American*. Los Angeles boxing promoter and the publicity spokesperson for the Dominguez air meet, Dick Ferris (inset), purchased the *American*. His wife, Florence Stone, christened it the *Dick Ferris* on its maiden voyage with its new name. On Wednesday, January 12, when the *New York* was sent out, it was followed by the *Dick Ferris* piloted by Charles F. Willard and George O. Duesler. (John Underwood.)

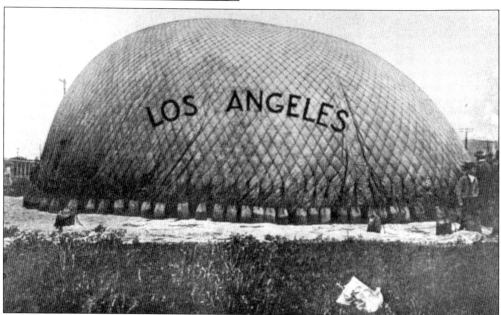

A postcard from an Aviation Meet Souvenir Folder shows a fourth balloon at the meet, the *Los Angeles*. Owned and operated by George B. Harrison, the balloon was too large for the limited resources of hydrogen at Huntington Park balloon field. Photographs show it was only partially inflated. Harrison joined C. B. Harmon and assisted him with pilot duties on the *New York*. (John Underwood.)

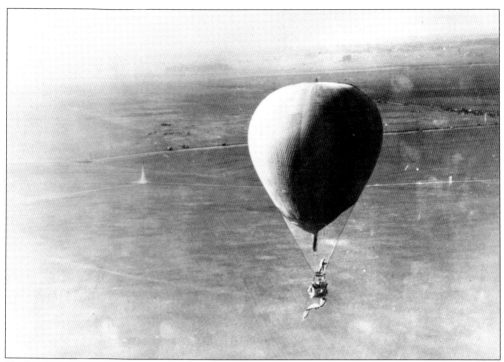

On January 12, the balloon *New York* left Huntington Park with pilots Harmon and Harrison and dignitaries Nat Goodwin, Celeste Paulhan, her friend Marquise de Pennendreff, and others. The *Peoria* left next, but it drifted to the north. The *American*, renamed and christened the *Dick Ferris* on this day, left last. The *New York* is seen crossing over the track circuit (the pylons are located at the west end of the field). It arrived with a bump at the west end of Aviation Field and was towed by groundskeepers to the front of the grandstand. (CSUDH.)

The balloon *New York* is towed safely at Aviation Field. George B. Harrison is in the rigging, and the balloon's owner/pilot Clifford Harmon and other dignitaries are in the basket. (Hatfield.)

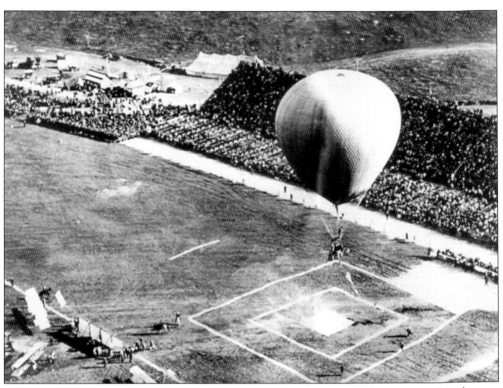

Above, an exuberant crowd in the grandstand greets the dignitaries about to disembark from the balloon *New York*. (Hatfield.)

Been Up in the Air for a Few Days

LOS ANGELES

WELL I'M BACK AGAIN

ANGELENO

BUSINESS

This Los Angeles *Express* cartoon appeared on the last day of the meet. It expresses the overall sentiment that Angeleno businessmen will be back and will probably arrive by balloon. (CSUDH.)

Six

THE PROGRAM, EVENTS, AND THE GRAND FINALE

Official programs were printed daily and were available at a cost of 10¢. They stated the rules for competitive events and the various prizes. Each day's program had a unique name:

Monday, January 10—Aviation Day
Tuesday, January 11—Los Angeles Day
Wednesday, January 12—San Diego Day
Thursday, January 13—Pasadena Day
Friday, January 14—Southern California Day
Saturday, January 15—San Francisco Day
Sunday, January 16—Special Day
Monday, January 17—Free Harbor Day
Tuesday, January 18—Ladies Day
Wednesday, January 19—Arizona Day
Thursday, January 20—Merchants and Manufacturers Day

On the afternoon of January 20, the 11th and final day of the meet, and before any flying activities could take place, a parade with the theme "From Ox-cart to Airplane" was staged. A farewell ceremony followed, where D. A. Hamburger, chairman of the Aviation Committee, expressed his appreciation to the participants and announced the prizewinners and runners-up:

Speed, 10 laps (16.11 miles): $3,000, Glenn Curtiss, 23:43 3/5, first; $2,000, Louis Paulhan, 24:59 2/5, second; $500, Charles Hamilton, 30:34 3/5, third. Endurance and Time: $3,000, Paulhan, 75.77 miles, 1:52:32, first; $2,000, Hamilton, 19.44 miles, 39:00 2/5, second; $500, Curtiss (same time as speed), third. Altitude: $3,000, Paulhan, 4,165 feet, first; $2,000, Hamilton, 330.5 feet, second; no prize money, Curtiss with no official height taken, third. Three laps with a passenger: $1,000, Paulhan, 4.83 miles, 8:16 1/5, no others contested. Slowest Lap (1.61 miles): $500, Hamilton, 3:32 (27 miles per hour average). Fastest Lap (1.61 miles): $500, Curtiss, 2:12 (43.9 miles per hour average). Shortest Distance Takeoff: $250, Curtiss, 98 feet. Quickest Time Takeoff: $250, Curtiss, 6.4 seconds. Accuracy: $250, Charles Willard, starting from a 20-foot square, making a circuit of the course, and landing in the same square. Solo Cross-country: $10,000, Paulhan, to Santa Anita and return, 45.1 miles, 1:2:42 1/5. Cross-country with passenger: no prize money, Paulhan with Celeste Paulhan, to Redondo Beach and return, 21.25 miles.

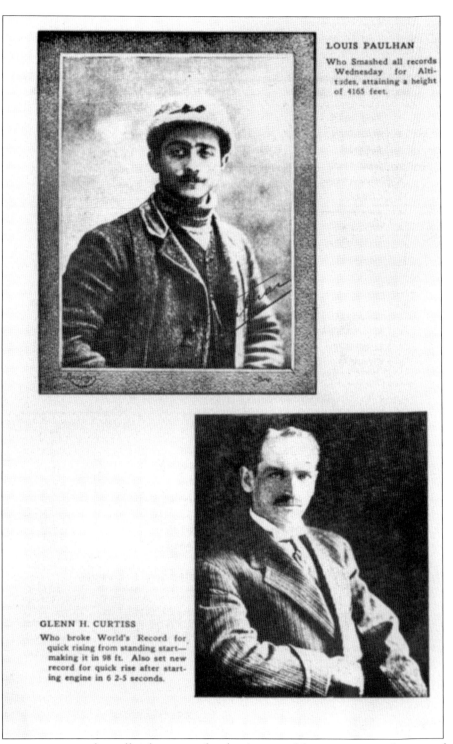

LOUIS PAULHAN

Who Smashed all records Wednesday for Altitudes, attaining a height of 4165 feet.

GLENN H. CURTISS

Who broke World's Record for quick rising from standing start— making it in 98 ft. Also set new record for quick rise after starting engine in 6 2-5 seconds.

The outer two pages of an official program for the Aviation Meet are seen in this spread. On the left is the last page, with the photographs of two of the finest aviators who flew at the meet, Louis Paulhan and Glenn Curtiss. On the right is the cover, showing a reproduction of the meet's

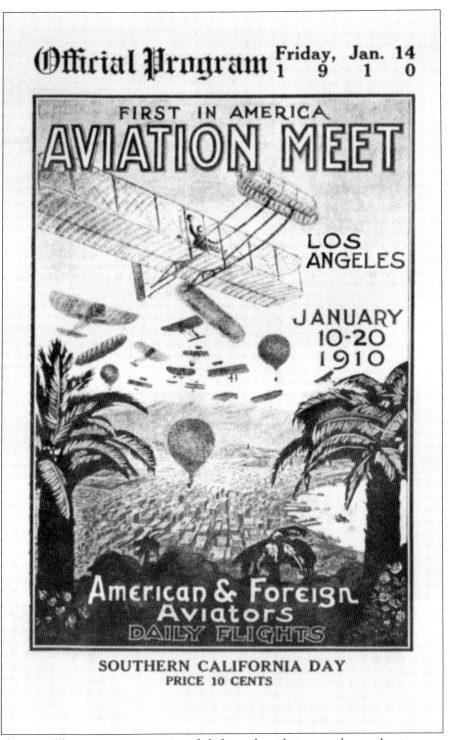

official poster. The programs were printed daily, each with its own date and unique program name. This one is for Friday, January 14, 1910, Southern California Day. The four-page program was 10¢. (CSUDH.)

OFFICERS OF THE MEET

EXECUTIVE COMMITTEE

D. A. HAMBURGER .. CHAIRMAN
F. J. ZEEHANDELAAR .. SECRETARY
P. F. WEIDNER ... TREASURER
 DICK FERRIS M. C. NEUNER FRED L. BAKER

AVIATION COMMITTEE

DICK FERRIS .. CHAIRMAN
 CORTLANDT F. BISHOP EDWIN CLEARY JEROME S. FANCUILLI

JUDGES

CORTLANDT F. BISHOP .. CHAIRMAN
H. LaV. TWINING ... VICE CHAIRMAN
 M. C. NEUNER PAUL W. BECK DICK FERRIS WM. C. STEPHENS
 ALTERNATES—A. L. SMITH, GEO. B. HARRISON.
W. H. LEONARD, SEC'Y TO JUDGES

PROGRAM

All Aviators before starting must notify the judges for which prize they are about to compete. The time of starting will be taken when the aeroplane crosses the line between the two posts opposite the grandstand in flight. All eroplanes must make a complete circuit outside of the pylons and there will be a judge stationed at each end of the field to see that no aeroplane passes inside the posts. All aeroplanes must proceed in a direction contrary to the movement of the hands on a watch; that is, from left to right down the hill and around the course. If for any reason aviators desire to stop they should, if possible, proceed inside the course in order to remain out of the track of other aeroplanes. Aviators must not fly over the grand stand or any place where a crowd is assembled without permission of the judges. Aviators violating this rule will be penalized. In contests for height prizes, aviators must start in the usual direction, proceed around the course, and then pass over a balloon which will be suspended somewhere near the judges stand. Arrangements will be made to calculate the highest altitude attained at or about a point above the balloon mentioned. They must then proceed across to the course and around, always in the same direction

Aviators who do not make a flight every day between the hours of two and five o'clock p. m. of one complete circuit of the course in competition for the speed or endurance contests will be penalized five per cent of their best time for the prize. The length of the course is one and sixty-one one-hundredths (1.61) miles.

For the various prizes offered an aviator is at liberty to compete at any time after two o'clock on the days of the Meet. He can make as many attempts as he wishes to lower his record and the prize will be awarded on the basis of the classification made at the end of the Meet on January 20th.

Competitors have the right of appeal for fifteen days to the Aero Club of America from any decision of the judges, and after that period the prizes will be paid to the winner.

The prizes will be awarded as follows:

A Speed Prize for the best ten laps during the Meet of $3000, $2000, and $500.

Endurance Prize for the aeroplane covering the greatest distance in continuous flight $3000, $2000, and $500.

Prize for the Highest Altitude Reached $3000, $2000, and $500.

Passengers Carrying Prize for the aeroplane making the best time carrying a passenger for three laps of the course, the passenger to weigh one hundred and fifty pounds (any deficiency to be supplied by ballast), $1000 and $500.

A prize of $500 will be awarded to the aeroplane which makes the slowest lap at any time during the Meet.

A starting prize of $250 will be awarded to the aeroplane which leaves the ground in the shortest distance at any time during the Meet. Another prize of $250 will be awarded to the aeroplane leaving the ground in the shortest time during the Meet.

A prize of $1000 will be awarded for the fastest lap made by any aeroplane on any day during the Meet.

A prize of $250 will be awarded to any aeroplane which starts from a rectangle twenty-five feet square, making a circuit of the course, and landing in the same rectangle.

Timing will cease one-half hour after sunset and no credits will be given for any subsequent performance.

These were the two inside pages of the official program. On page two (left), one reads about the officers of the meet, the committees, and the judges. Below this are details of the program, rules and regulations, the event's description, and monetary awards. On page three (right), the aviators and aeronauts are listed alongside their flying machines in groups: Aeroplanes, Dirigible Airships, and Balloons at Huntington Park. Useful aids for those keeping score are the grids and the printed

AEROPLANES

NO.	AVIATOR	MACHINE	LAPS	TIME
1	PAULHAN	Farman Biplane.....
2	PAULHAN	Bleriot Monoplane
3	MASSON	Bleriot Monoplane
4	MISCAROL	Bleriot Monoplane
5	HAMILTON	Curtiss Biplane
6	CURTISS	Curtiss Biplane
8	KNABENSHUE	Wright Bros. Biplane with Curtiss Chassis
9	WILLARD	Curtiss Biplane
10	H. W. GILL	Gill-Dosh
11	HARMON	Curtiss Biplane.....

DIRIGIBLE AIRSHIPS

NO	PILOT	DIRIGIBLE	ALTITUDE	DISTANCE	TIME
11	ROY KNABENSHUE.......	5500 Cubic feet.
2	L. BEACHY	5500 Cubic feet.
3	LIEUT. BECK (Gov't Dirigible).	20,000 Cubic feet.
			

BALLOONS AT HUNTINGTON PARK

NO.	BALLOON	PILOT	LANDED	ALTITUDE	TIME
1	THE DICK FERRIS......	KNABENSHUE
2	CITY OF LOS ANGELES .	GEO. B. HARRISON
3	NEW YORK	C. B. HARMON
4	PEORIA	FRANK J. KANNE
5	CITY OF OAKLAND	J. C. MARS
6	CO. A SIGNAL CORPS....	CHAS. D. COLBY
7	THE FAIRY	A. C. PILLSBURY....

Records for the above balloons may be taken from the newspapers the following morning

Official Records of Yesterday's Events

Glenn H. Curtiss, going ten laps around course in Curtiss Biplane. Time, 24 min. 54 2-5 sec. Average speed per lap, 2 min. 29 2-5 sec. Best time one lap, 2 min. 21 2-5 sec. Average speed per hour, 38.8 miles.

Louis Paulhan, going ten laps around course in Farman Biplane. Time, 24 min. 59 2-5 sec. Average speed per lap, 2 min. 30 sec. Best time one lap, 2 min. 28 2-5 sec. Average speed per hour, 38.65 miles.

Louis Paulhan, carrying one passenger (Mme. Paulhan), three laps. Time, 8 min. 16 1-5 sec.

Chas. D. Willard left 20-foot square and was awarded 100 points; also landed in 20-foot square, winning the prize of $250.

The fastest lap of the day was made by Glenn H. Curtiss. Time, 2 min. 21 2-5 sec.

summary at the bottom, "Official Records of Yesterday's Events." The records include aviator's name, event type and flying machine used, over what specified distance, best time, average speed or accuracy, and any prize money awarded. By providing each day's results, the Aviation Committee may have been trying to encourage spectators to follow their favorite aviators and their records. It is not much different from the handicapping of horses on race tracks. (CSUDH.)

These are two examples of the front covers for postcard memorabilia. In the view folder above, the early version contained 17 different aviators and their flying machines. In the keepsake of Official Souvenir Views (below), there were only six postcards—a notable unit price difference in only one week, as both sold for only 15¢. Almost anyone could own picture postcards of their favorite aviators or personages who were at the meet. (Above, CSUDH; below, John Underwood.)

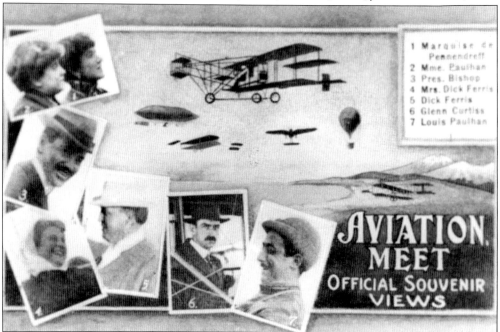

Enterprising businesses capitalized on aviation fever. Shapiro Music Publishers' sheet music (on right) was decorated with biplanes and featured the catchy new hit title, "Come Josephine in My Flying Machine." Eva Swomley recorded this song on vinyl. The colorful card below, captioned "Greetings from Los Angeles, California— Aviation Week," presented a sky full of aircraft. It was only one of dozens of postcards that gave the senders bragging rights that they had really been there. (Both, CSUDH.)

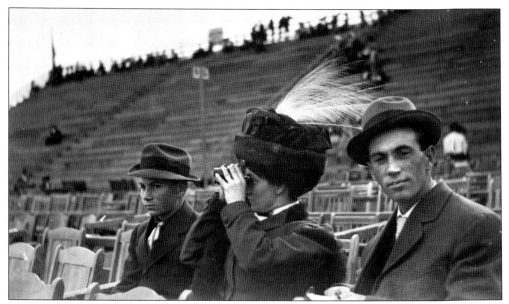

At left, Lawrence Bell, the future Bell helicopter developer and manufacturer, is seen with his sister and brother attending an air meet at Dominguez Hill. Aviators and their machines flying through the Los Angeles sky could best be seen with binoculars, which his fashionable sister uses. (TMOF/Hatfield.)

A Los Angeles *Times* cartoonist provides a wry look at spectators and the peculiar exercises they performed during air meets at Dominguez field. This cartoon comes from the Los Angeles *Times* in January 1912. (CSUDH.)

The Whitley Jewelry Company offers fashionable ladies the celebrated Lemaire field glasses from $17 to $23 and the Perplex binoculars with eight-power lenses at $40, which are indispensable for spectators attending the air meet. (CSUDH.)

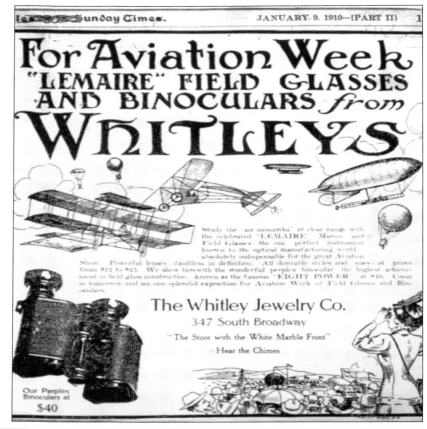

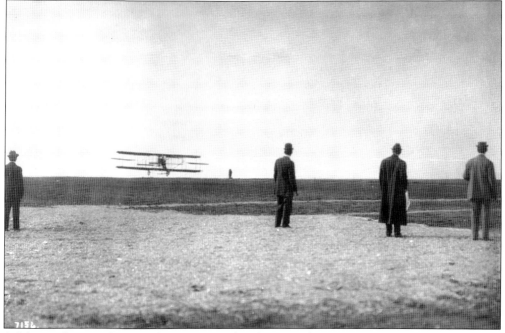

Sideline judges watch a low-flying Curtiss Flier. (CSUDH.)

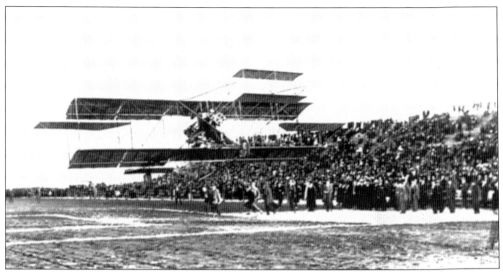

Glenn Curtiss in his Rheims-type Flier set two world records for both leaving the ground in 6 and 2/5 seconds and for clearing his wheels from the ground in 98 feet. Both of these events were accomplished on the same flight and were measured from the moment his crew swung the propeller through. (CSUDH.)

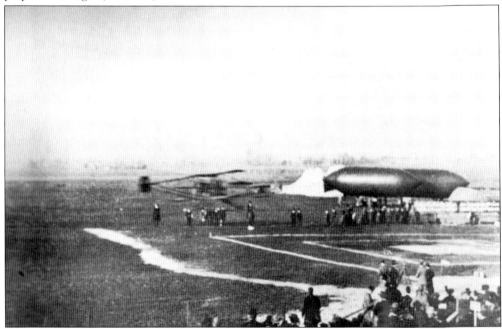

Charles Willard won the accuracy contest in his *Golden Flier* with a perfect score. Starting from a 20-foot square, he completed one circuit of the course and landed in the same square. A reporter described the thrilling event: "The crowd now saw that he was attempting to land within the square. Willard was short of his goal but jockeyed the throttle, playing with power and skimmed over the ground. He cut the power again while checking his momentum and glided the Flier a hundred feet more. He landed on the same spot from which he had taken off a few minutes earlier. The spectators gave him a rousing cheer for his effort." This incident was relayed by J. Wesley Neal from an article in the Los Angeles *Times* on January 14, 1910. (CSUDH.)

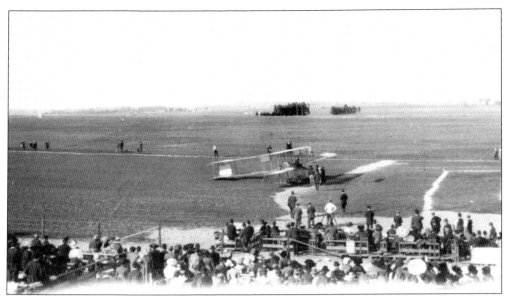

Above, Louis Paulhan, after notifying the judges that he was about to take off for the altitude competition, prepares for his flight. "Measurement takers," as judges for this event were called, stationed two survey transits at the ends of a long baseline of known length beneath the tethered balloon *Examiner*. Below, soon after, Paulhan takes off on his attempt for the highest altitude prize. He crosses the white marked squares in front of the grandstand. Today is the third day of the meet, January 12, 1910, San Diego Day. A large contingency arrived from San Diego by train and automobiles and brought with them thousands of pennants and 50,000 buttons to promote the Panama–San Diego Exposition planned for 1913. (Above, John Underwood; below, CSUDH.)

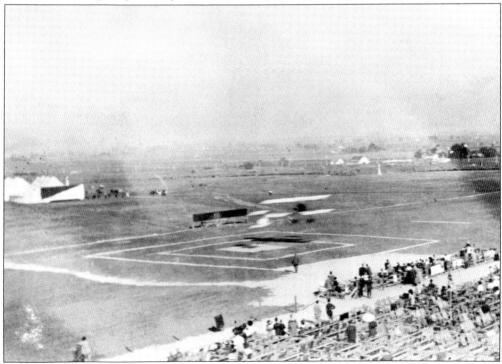

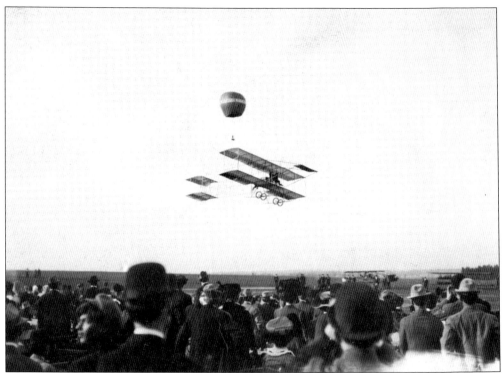

Paulhan circles around the *Examiner* balloon as he gains altitude. From the grandstand looking northwest, a photographer took this image of Paulhan's ascent to an altitude record. (CSUDH.)

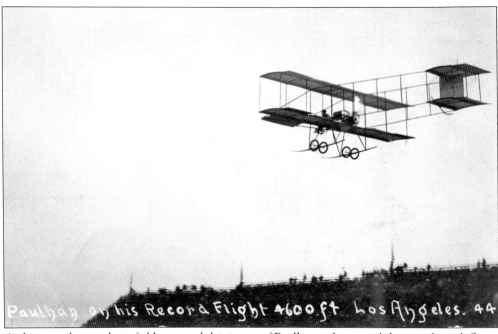

Paulhan on his Record Flight 4600 ft Los Angeles. 44

A photographer on the infield captured this image of Paulhan as he passed the grandstand, flying the Farman biplane higher and higher. (John Underwood.)

On the third day of competition, Louis Paulhan passes beneath the tethered *Examiner* balloon on his way to achieving a world record. The balloon was used by the judges to calibrate their transits for altitude calculations. (CSUDH.)

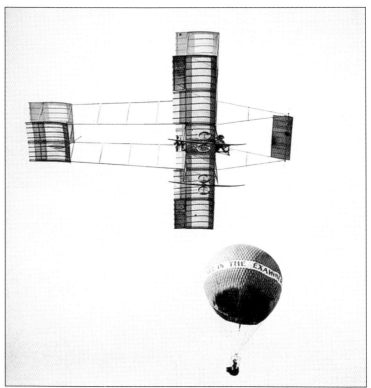

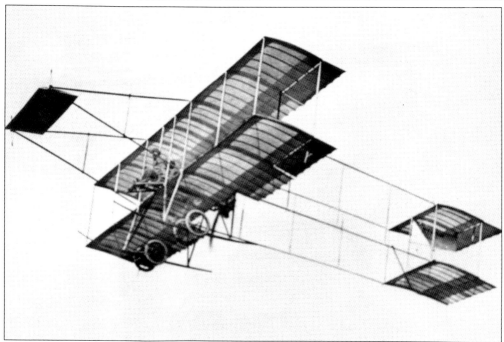

As it struggles at the ceiling limit for the air-cooled Gnôme engine, the aeroplane's upward momentum comes to rest. When the plane just begins to return to earth, judges at the survey transits lock in the angles of ascension they observed with their instruments. (CSUDH.)

Official judges included students and faculty members of Los Angeles Polytechnic High School. With the two angles these transits made and with a known baseline distance between them, using a trigonometry table made it an easy calculation to establish the height to which the airplane went. Although Paulhan had taken a barograph aloft, which registered 1,525 meters (or just over 5,000 feet), someone in the crowd removed it from the Frenchman's plane after his return, and the judges' computation had to be taken as the official height. In this case it was 4,165 feet, surpassing Hurbert Latham's achievement of 3,444 feet just 10 days earlier. (Hatfield.)

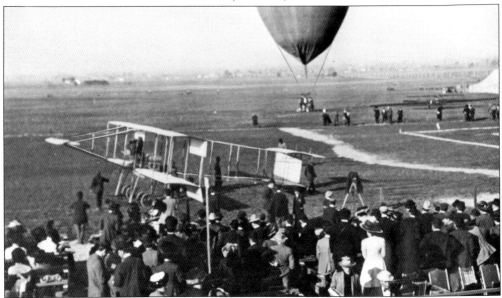

Louis Paulhan in his standard Farman biplane with its large gas tank just returned from a world-record altitude flight of 4,165 feet, and photographers are seen recording the event while the balloon *New York* silently rests in the background. Paulhan accomplished this feat in 43 minutes and 16½ seconds. The descent took only 7½ minutes. Results of the baseline and transit recording method taken by the judges on the infield became the official record, and Paulhan was verified as the first-place winner. (CSUDH.)

On Tuesday, January 18, Ladies Day, the winds were 30 miles per hour with even higher gusts. All aviators except for Louis Paulhan put their machines back into the tents. After one trial lap takeoff and landing practice, Paulhan took off at exactly 3:00 p.m. As the band played "La Marseillaise," he flew past the tethered *Examiner* that was beginning to collapse because of the winds and went past pylon No. 1, circling higher and higher, heading north in the direction of Baldwin Park. (CSUDH.)

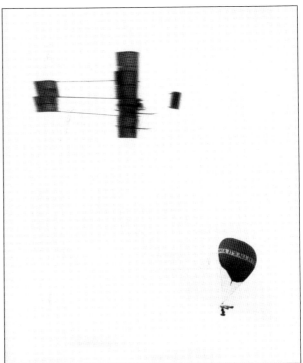

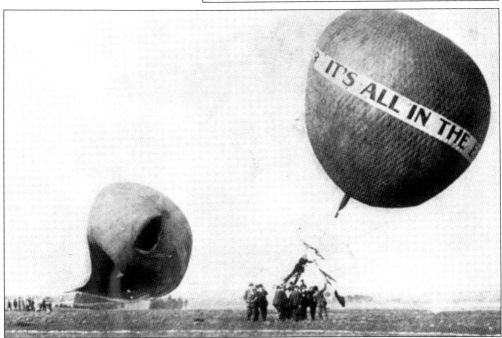

This view shows further evidence of the ferocity of the wind on January 18. When Paulhan was well on his way to Arcadia for his solo cross-country run, the balloon *New York* arrived from the Huntington Park field. It and the *Examiner* were in imminent danger of being swept away. Clifford Harmon, in order to save the $5,000 bag, pulled the seam cord on the *New York* to release all of its hydrogen. The *Examiner* team finally corralled the balloon and anchored it. (TMOF/Hatfield.)

Paulhan (above) set a world record for solo cross-country endurance for his 45.1-mile flight to and from Santa Anita in 1 hour, 2 minutes, and 42 4/5 seconds, averaging 43.15 miles per hour. A triumphant Paulhan is carried on the shoulders of a spectator, but he did not like this and asked to be put down. Meanwhile, exuberant fans smile and cheer him on. Below, Paulhan is swarmed by a crowd running up to his plane, shortly after he alighted from this flight, on January 18, 1910. He also won $10,000 in prize money for this event. (Above, CSUDH; below, Hatfield.)

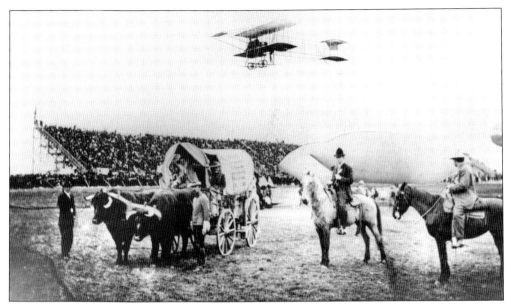

The last day of the meet, Thursday, January 20, 1910, was met with threatening rain. There was no activity until noon. Before any flying was to take place, a parade was scheduled as the finale. The Los Angeles Merchants and Manufacturers Association presented a history of transportation in a grand parade called "Ox-cart to Airplane." It was led by a brass band playing "La Marseillaise" in honor of Louis Paulhan and his countrymen. Ezra Meeker's Oregon Trail oxcart came next. (LAPL.)

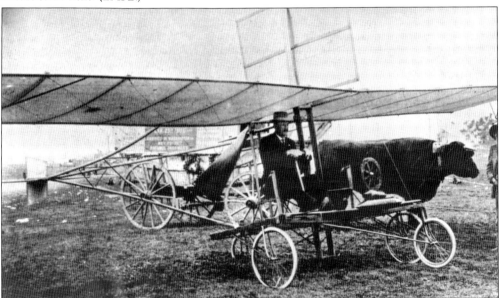

Ezra Meeker is seated in the Eaton-Twining monoplane. His Oregon oxcart is in the background. A clever photographer set up this scene to show Meeker making a literal move from oxcart to airplane. After the parade concluded, spectators approached to look at the parade entrants. It was reported that after the parade and ceremony, even after someone explained to Paulhan, who did not understand a word of English, that the oxcart was the one that marked the Oregon Trail, Paulhan asked, "What is an Oregon?" (CSUDH.)

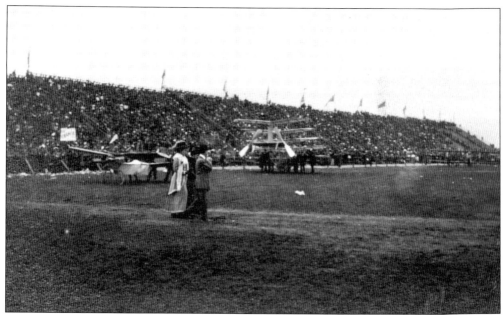

This stereograph shows the section of the parade that included planes that either did not or could not fly. Bringing up the rear was Edgar Smith's *Dragonfly II*, then Zerbe's multiplane. This was followed by airplanes that did fly, beginning with Curtiss's Flier in the front. (CSUDH.)

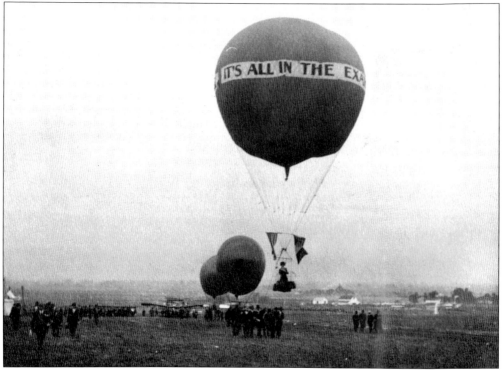

Another stereograph shows a fashionable woman aloft in the *Examiner* balloon. The balloon, guided along the parade route by two groups of strong men holding ropes, preceded the two dirigibles designed by Roy Knabenshue and flown by him and Lincoln Beachey. (CSUDH.)

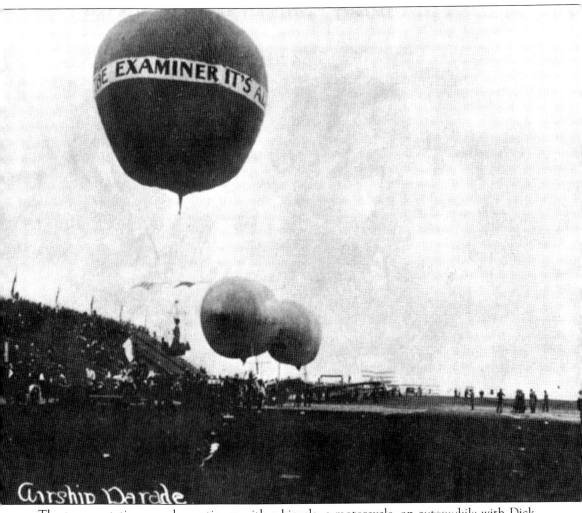

Airship Parade

The transportation parade continues with a bicycle, a motorcycle, an automobile with Dick Ferris and his wife, Florence Stone, as passengers, a large spherical balloon—the *Examiner*, with a woman passenger—two dirigibles towed by militiamen, the airplanes, and, finally, the aviators walking side by side. The only mishap during the parade was that a burro tried to chew off the wing of an airplane. (TMOF/Hatfield.)

The aviators and aeronauts bring the transportation parade to a climax and a close: The aviators walked in rows past the grandstand. One row seen here consisted of, from left to right, Jerome Fanciulli (Curtiss's business manager), Glenn Curtiss, Didier Masson, Louis Paulhan, Charles Miscarol, Charles Willard, and Hillery Beachey. (CSUDH.)

After marching in the Transportation Parade, on January 20, 1910, the aviators and aeronauts who actively participated in the air meet pause near the east end of the grandstand for a photographic opportunity. Seen in the front line from left to right are Hillery Beachey, Col. Frank Johnson, Glenn Curtiss, Louis Paulhan, Charles Willard, Didier Masson, Lincoln Beachey, Roy Knabenshue, and Charles Hamilton. Novice pilots who participated but are not pictured are Edgar Smith, Charles Miscarol, and Clifford Harmon. (CSUDH.)

Seven

A CENTURY OF FLIGHT

The January 1910 air meet was an extraordinary gathering of individuals. Charles Willard, the aviator, and Roy Knabenshue, the balloon and dirigible pilot, are two well-known participants of the meet who remained actively involved with aviation in Southern California until their death. They were daredevils of their time, as flying was experimental and dangerous in the early days, but both were circumspect aviators and defied an early demise.

The air meet was an inspiration to many who attended. It was the seed for Los Angeles's growth as a center of aeronautical development and manufacturing. Some of the men became famous titans of aviation manufacturing in California: Glenn Martin, Lawrence Bell, Donald Douglas, and James "Dutch" Kindelberger (founder of North American Aviation). Others became famous for manufacturing outside of California: William Boeing, enthralled with aviation at that time, went on to become one of this country's leading builders of cargo, military, and commercial aircraft in Seattle, Washington; and Glenn Curtiss continued to experiment and build aircraft and by 1913 was the largest manufacturer of aircraft in the United States.

Sadly, the airstrip no longer exists. The land was sold and turned into a mobile home park. But the historic event that took place on Dominguez Hill in January 1910 is not forgotten. The Dominguez Rancho Adobe Museum, through its unique connection with the Dominguez family, has kept the memory alive and has maintained an active stewardship of early aviation memorabilia.

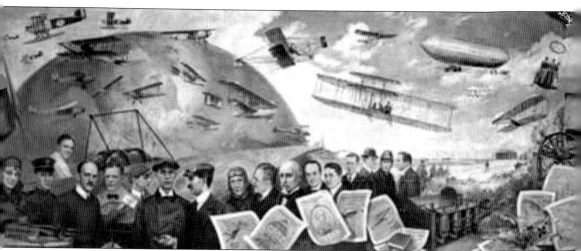

Justin Gruelle's *Early Birds Mural* traces the early history of aviation. It is a fitting tribute to the pioneers of aviation and their aircraft, all of which the artist depicted with great accuracy and detail. In 1970, it was hung in the permanent collection of the Smithsonian Institution's Art Wing in Washington, D.C. The organization of old-timers formally known as Early Birds, Inc., included Charles Willard and Roy Knabenshue. The basis for membership in the Early Birds was solo flight prior to December 17, 1916, the date before America entered World War I. For European pilots, the cut-off date was prior to August 4, 1914. (CSUDH.)

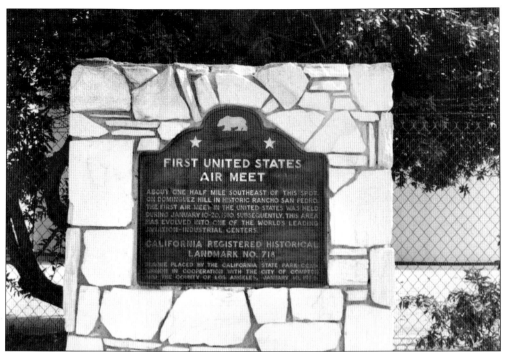

A bronze tablet set in stone commemorates the 50th anniversary of the 1910 Los Angeles International Aviation Meet. It is designated California Registered Historical Landmark No. 718. About a half mile southeast of the aviation meet's actual location, it is located on Wilmington Avenue in Carson, north of Del Amo Boulevard near Glenn Curtiss Street. Aviators Charles Willard, Roy Knabenshue, Harvey Crawford, and George Barnhart were the honored guests at the celebration on January 24, 1960. (CSUDH.)

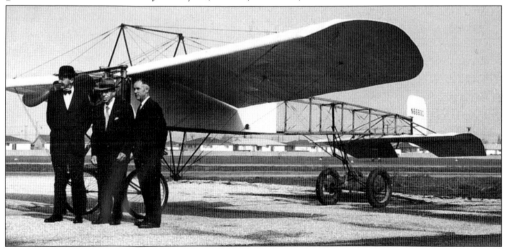

Roy Knabenshue (center) is on his way to deliver the introductory speech at the air meet's 50th anniversary celebration on January 24, 1960. Frank Tallman (left) and Roy's son, Glenn (right), pose with him in front of a replica of the Blériot XI, which Tallman flew from Compton Airport to Dominguez Hills. Soon after, Knabenshue suffered a stroke and passed away in Temple City, California, on March 6, at the age of 83; he is interred at the Portal of the Folded Wings in North Hollywood, California. (Photograph by John Underwood.)

The original plaque commemorating the "First Air Meet" was installed by the Native Sons and Native Daughters of the Golden West on June 8, 1941. The plaque was moved and rededicated on January 24, 1960. It was again moved and rededicated on December 10, 1974. The plaque has been reset in stone. Catherine Erven (left), supervisor and deputy grand president, and Betty Linn, chairwoman of historical and landmark committees for the Native Daughters, hold in their hands the small rededication plaque that was placed alongside the original. (CSUDH.)

From left to right, Bert Gilhousen (an Early Bird and a 1910 event organizer), Betty R. Curlich (a Native Daughter of the Golden West), Hazel B. Hansen (whose name appears on the plaque), and Dr. Leo Cain (president of California State University, Dominguez Hills) admire the plaque at the formal dedication and remarking of the site of the "First Air Meet" in the United States, on Tuesday, December 10, 1974, at the California State University, Dominguez Hills. (CSUDH.)

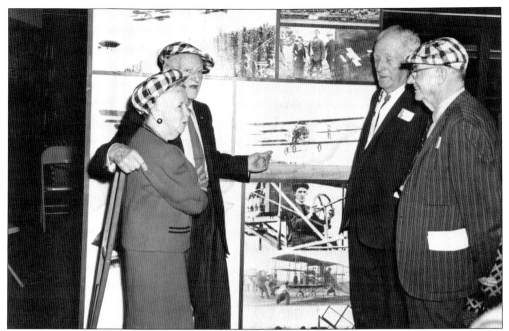

Charles Willard and Georgia "Tiny" Broadwick, the "First Lady of Parachuting," were Early Birds in attendance at a reunion and banquet of aviators in 1969. They are pictured with Early Bird Forrest Wysong (far right) and next to him, an unidentified man. The checkered cap identifies them as members of the Early Birds. (CSUDH.)

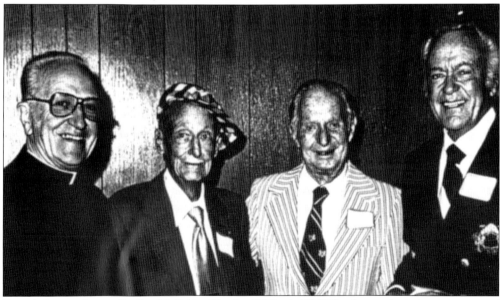

From left to right are Fr. Pat McPolin, Charles Willard, Cliff Henderson (aviation promoter of the National Air Race at Mines Field/LAX), and Charles "Buddy" Rogers, star of the 1927 movie *Wings* and Mary Pickford's husband. After his death in 1977, Willard's Early Bird hat and pin, gold medal from the January 1910 air meet, his aviation instruments, and other memorabilia were donated to the museum where they are on display in the Early Bird Room. The photograph was taken in 1969. (CSUDH.)

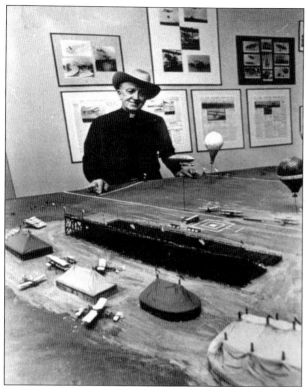

On January 16, 1977, Fr. Pat McPolin, museum creator and curator (between 1974 and 2001), opened to the public the 1910 Air Meet Room, whose main feature is a diorama of Aviation Field. The room's opening coincided with a fly-in of antique planes and an antique auto show, which were all part of a commemoration of the 1910 air meet. The fly-in marked the last flying into and out of Dominguez Hills. This photograph was taken by the author in 1990. (Photograph by Kenneth E. Pauley; DRAM.)

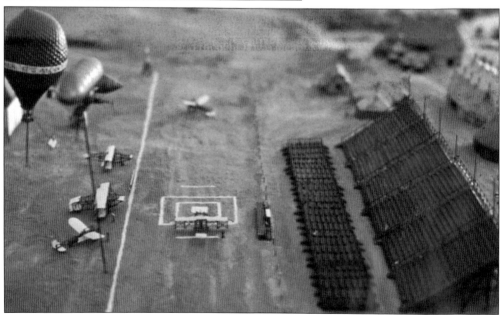

The Air Meet Room features a 7-by-12-foot scale-model diorama of Aviation Field and models of the Curtiss *Golden Flier*, a Blériot monoplane, and a Farman biplane. The diorama's design was based on eyewitness accounts from flyers, 1900 survey maps, and pictures of the event. The display brings to life the sights and sounds of the field, the planes, grandstands, balloons, and the tents collectively known as "aviation camp." (CSUDH.)

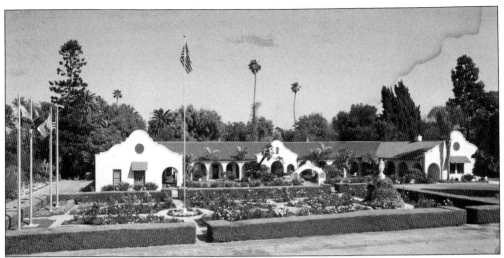

The Dominguez Rancho Adobe was the Dominguez family home. Donated to the Claretians by the Dominguez daughters, it was used as a Claretian Seminary up until 1927 and was restored in two phases. Upon completion of restoration, it was opened as a historical museum for visitors. Its registration as a landmark was approved by the U.S. Department of Interior on May 28, 1976. A plaque was unveiled on September 12, 1976, commemorating the 150th anniversary of the homestead adobe. (DRAM.)

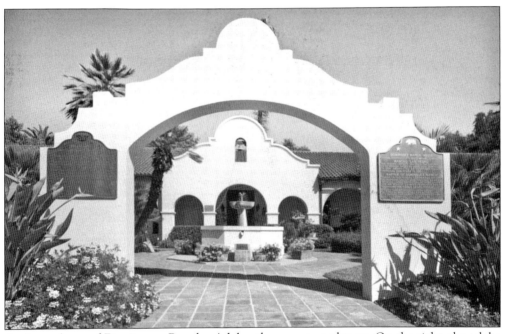

At the archway of Dominguez Rancho Adobe, there are two plaques. On the right, the adobe is designated Historical Landmark No. 152 and also mentions the battle that took place on the rancho property, the Battle of Dominguez Hill. On the left, the adobe is placed on the Department of Interior's National Register of Historic Landmarks. (DRAM.)

THE FASHION OF THE WEEK.

LOS ANGELES

Aviation was more than January 1910's fashion of the week. It has endured for a century. America's First International Air Meet brought aviation to the attention of a public who became convinced that airplanes were no longer just for sport and launched transportation into the modern age. (CSUDH.)

Aviation in Southern California began here at Dominguez Hill on January 10, 1910. This plaque commemorating the First International Air Meet held in the United States, second in the world, was placed on the historic Dominguez Hill in 1941. The Dominguez daughters could not have imagined that allowing the use of their property for an air meet in 1910 would have had the lasting results that it did. The Dominguez family legacy, through the Dominguez Rancho Adobe Museum, and the dream of aviation live on. The year 2010 marks the 100th anniversary. (CSUDH.)

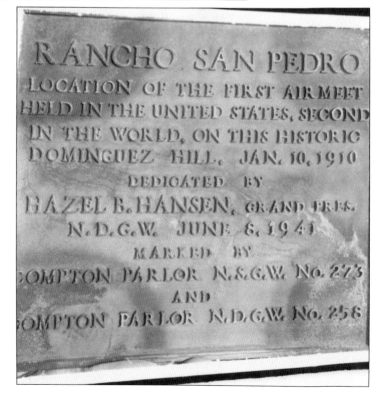

RANCHO SAN PEDRO
LOCATION OF THE FIRST AIR MEET
HELD IN THE UNITED STATES, SECOND
IN THE WORLD, ON THIS HISTORIC
DOMINGUEZ HILL, JAN. 10, 1910
DEDICATED BY
HAZEL B. HANSEN, GRAND PRES.
N.D.G.W. JUNE 8, 1941
MARKED BY
COMPTON PARLOR N.S.G.W. No. 273
AND
COMPTON PARLOR N.D.G.W. No. 256

BIBLIOGRAPHY

Almond, Peter. *Aviation: The Early Year.* Köln: Könemann Verlagsgesellschaft mbH (The Hutton-Getty Picture Collection), 1997.

Boyne, Walter J. *The Smithsonian Book of Flight.* New York: Orion Books, 1987.

Casey, Louis S. *Curtiss: The Hammondsport Era, 1907–1915.* New York: Crown Publishers, 1981.

Chant, Christopher. *A Century of Triumph: The History of Aviation.* New York: The Free Press, 2002.

Culick, Fred E., and Spencer Dunmore. *On Great White Wings.* Toronto and Ontario, Canada: Madison Press Books, 2001.

Field, Charles K. "On the Wings of To-Day." *Early Flight: From Balloons to Biplanes,* Frank Oppel, ed. Secaucus, NJ: Castle Inc., 1987; also in *Sunset Magazine,* March 1910: 145–252.

Gillingham, Robert Cameron. *The Rancho San Pedro.* Los Angeles, CA: Cole-Holmquist Press, 1961.

Harris, Sherwood. *The First to Fly: Aviation's Pioneer Days.* New York: Simon and Schuster, 1970.

Hatfield, David D. *Dominguez Air Meet.* Inglewood, CA: Northrop University Press, 1976.

Kyne, Peter B. "Worm's-Eye Views of Flying Men." *Sunset: The Magazine of the Pacific and of All the Far West* Vol. XXVI, No. 3 (March 1911): 281–286.

Longyard, William H. *Who's Who in Aviation History: 500 Biographies.* England: Airlife Publishing, 1994.

Neal, J. Wesley. "America's First International Air Meet." *The Historical Society of Southern California Quarterly* Vol. XLIII, No. 4 (December 1961): 369–414.

Schoneberger, William A. *California Wings: A History of Aviation in the Golden State.* Woodland Hills, CA: Windsor Publications, 1984.

Villard, Henry Serrano. *Blue Ribbon of the Air: The Gordon Bennett Races.* Washington, D.C.: Smithsonian Institution Press, 1987.

———. *Contact: The Story of the Early Birds.* Washington, D.C.: Smithsonian Institution Press, 1987.

Wright, Wilbur and Orville. *Miracle at Kitty Hawk: The Letters of Wilbur and Orville Wright.* Edited by Fred C. Kelly. New York: Da Capo Press, 2002.

www.arcadiapublishing.com

Discover books about the town where you grew up, the cities where your friends and families live, the town where your parents met, or even that retirement spot you've been dreaming about. Our Web site provides history lovers with exclusive deals, advanced notification about new titles, e-mail alerts of author events, and much more.

Find Your Place in History.